POSTCARD HISTORY SERIES

Hattiesburg

in Vintage Postcards

Reagan L. Grimsley

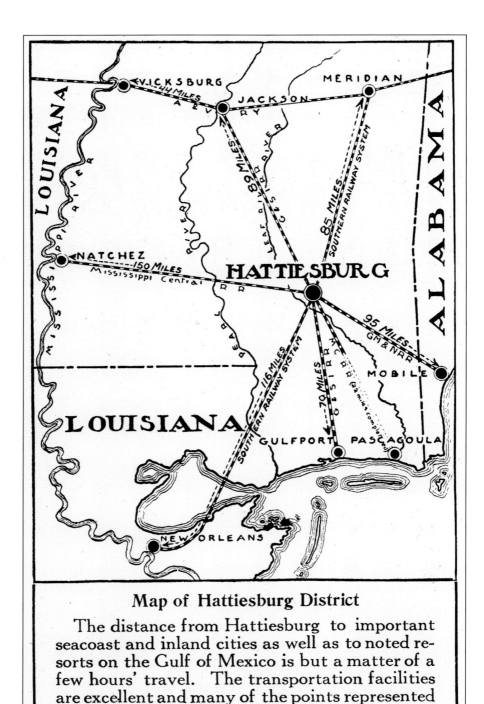

Map of Hattiesburg District

The distance from Hattiesburg to important seacoast and inland cities as well as to noted resorts on the Gulf of Mexico is but a matter of a few hours' travel. The transportation facilities are excellent and many of the points represented above are reached without changing trains.

Aptly named the "Hub City," Hattiesburg and its central location in the heart of Mississippi's piney woods is depicted in this *c.* 1920 map from a postcard folder.

POSTCARD HISTORY SERIES

Hattiesburg

IN VINTAGE POSTCARDS

Reagan L. Grimsley

Published by Arcadia Publishing
Charleston SC, Chicago IL, Portsmouth NH, San Francisco CA

Printed in Great Britain

Library of Congress Catalog Card Number: 2004109158

For all general information contact Arcadia Publishing at:
Telephone 843-853-2070
Fax 843-853-0044
E-mail sales@arcadiapublishing.com
For customer service and orders:
Toll-Free 1-888-313-2665

Visit us on the internet at http://www.arcadiapublishing.com

CONTENTS

Acknowledgments 6

Introduction 7

1. The Hub City 11

2. Churches 55

3. Hotels, Motels, and Roadside Stops 61

4. Center of Higher Education 73

5. Camp Shelby 85

6. Send Me a Postcard 123

Bibliography 127

Index 128

ACKNOWLEDGMENTS

No work is completed without the assistance of others. In particular, I would like to thank Yvonne Arnold, whose knowledge of the history of the University of Southern Mississippi was indispensable. In addition, the faculty and staff of the McCain Archives at the University of Southern Mississippi are to be commended for their prompt and courteous attention to my many requests. Likewise, DeNiecechsi Layton of the Mississippi Department of Archives and History went above and beyond the scope of normal reference service to provide access to the facility's postcard collections. The staff of Curt Teich Company Postcard Archives in Lake Forest, Illinois, was most helpful with identifying and dating the 150-plus postcards produced by the company. Fellow historian and postcard enthusiast Kenneth H. Thomas Jr. offered his guidance and knowledge of postcards for which I am grateful. A thank you is also extended to the interlibrary loan librarian at Columbus State University, Cheryl Hewitt, who put up with my many strange requests for books about the piney woods of Mississippi. The resources of the Mississippi Room at the main branch of the Library of Hattiesburg, Petal, and Forrest County were of great assistance in verifying facts for the work. Terri Kimble read the text and offered many suggestions to improve my syntax and contributed several photographs that greatly enriched the content. I am grateful to all of you for helping this volume come to fruition.

Although I no longer reside in the Pine Belt, I still consider the area "home," and I would like to thank all of the people who work to preserve and interpret the culture and history of the region; without you, so much of our legacy would be lost.

INTRODUCTION

Hattiesburg in Vintage Postcards traces the history of Hattiesburg and the surrounding area through one specific type of document: the postcard. Originally used as an inexpensive method of written communication, at the end of the 19th century, vendors began to print images on the reverse side of the cards. This adaptation created several unintentional uses for postcards that have made them useful well beyond the written messages they contain. The first unintentional use was the craze of postcard collecting. A second unintended use is the reason for this volume: utilizing the scenes and written messages on postcards as a tool to gain a broader understanding of the past of a specific location.

Soon after the first image-based postcards arrived in stores, people began to collect and trade individual cards. Taking advantage of this fad, postcard makers began to produce a wider variety of cards, including advertising cards, cards by specific artists, political cards, and perhaps the most popular, the view card. View cards often portrayed a particular locale and offered an image of a person, place, scene, or event that was unique to the area. Major postcard printers went to great lengths to provide a variety of cards, and the Curt Teich Company produced more than 150 views of the city of Hattiesburg over a period of 50 years. By 1913, nearly one billion postcards per year were mailed in the United States, and people across the nation were sending, receiving, and trading cards of buildings, natural wonders, businesses, vehicles, political figures, and more. The residents of Hattiesburg were no exception, as one citizen of the piney woods sent a view card of Main Street in Hattiesburg to a fellow collector in Ohio in 1937 with the inscription: "May I exchange view cards with you . . ." Obviously, the sender hoped for a similar Ohio view card in return to help build her collection. Postcard collecting as a hobby has not abated, as individuals today collect cards from specific regions or of a specific type of building, such as libraries or rail depots.

There remains, however, another unintended use of the postcard. The images on postcards and the written messages they contain are snapshots in time and can be used by scholars to reveal, and often reconstruct, the past. View cards are important tools for local historians as they are often the most readily available images of a town. Hattiesburg is no exception. Shortly after the dawn of the 20th century, photographer D.B. Henley produced a number of photograph-based postcards that, today, provide some of the most detailed views extant of Hattiesburg and the surrounding area. Some of these images, such as views of the once renowned Hotel Hattiesburg, are the only reminders of the existence of a structure. Other images can document the changes

in transportation, as can be viewed through street scenes of various time periods. The written messages on the back of cards can also unearth valuable information, an example being a 1939 card written from Mississippi Women's College that alludes to the stir caused by the theatrical release of *Gone With the Wind*. Through careful study, the past can once again come alive through the postcard.

This volume is not intended to be a narrative history of Hattiesburg. A basic understanding of the rich history of the city, however, can help place the postcard images in this volume in an appropriate context. The paragraphs that follow sketch out a brief history of the city and illuminate many of the people, places, and events that are featured in the book. Those interested in more detail should refer to the bibliography for other works that should be consulted to fully understand the exciting history of the "Hub City."

On Thanksgiving Day in 1912, residents of Hattiesburg, Mississippi, gathered downtown near the Ross Building to crown the success of their young city. Earlier in the year, the Commercial Club sponsored a contest designed to give Hattiesburg a slogan. R.R. Swittenburg penned the winning entry, "The Hub City," and soon thereafter, work began on an illuminated sign to be placed in a highly visible location. Erected by the Henry L. Doherty Company atop the Ross Building, the sign measured 42 feet in diameter and utilized 1,142 lights. It praised Hattiesburg as the central city in South Mississippi. Hattiesburg was still a fledgling city, not yet 30 years of age, but was riding high on a wave of prosperity brought about by the success of the lumber industry. Although the sign would disappear from the Hattiesburg landscape before the advent of World War II, the sign symbolically represented Hattiesburg taking its place alongside the other prominent cities of the region: Jackson, Meridian, Mobile, Gulfport, New Orleans, and Natchez.

The success of the city did not come easily. Although Mississippi became a state in 1817, much of the southeastern portion of the state, known locally as the piney woods, remained sparsely populated until the latter part of the 19th century. After 1880, however, change would come swiftly to the region as investors saw economic potential in the plentiful forests of longleaf pine that were the trademark of the area. Cities and towns came to life overnight as railroads pushed through the forests of yellow pine, creating new centers of industry and trade. Hattiesburg, Mississippi, was one of these towns.

In the summer of 1880, Capt. William Harris Hardy stopped to take a noontime rest from his duties as vice-president and attorney of the New Orleans and Northeastern Railroad. A firm believer in the potential of the piney woods, Hardy had worked tirelessly over the preceding 10 years to secure a railroad route from New Orleans to Meridian. As he settled in under an oak tree, Hardy began to review the map of the proposed route of the New Orleans and Northeastern. After careful study of the geographic features of the locale, Hardy became convinced that the nearby area, one mile from the confluence of the Leaf and Bouie Rivers, would be a natural route for a second rail line, one between the Gulf Coast of Mississippi and the capital at Jackson. According to his memoirs, Captain Hardy concluded the area would become a center of rail transport and develop into a town. In 1883, Hardy entered a claim for land adjoining the railroad, and in December of the same year, the post office at this location was named Hattiesburg. Hardy chose the name in honor of his second wife, Hattie. Although Hardy would later make his home in Hattiesburg, Hattie died in 1895, five years before Hardy moved to the city.

Incorporated in 1884, Hattiesburg grew rapidly. As Hardy predicted, the Gulf and Ship Island Railroad, a north-south route between Gulfport and Jackson, gave the city a second rail connection in 1897, although it was 1900 before the route was entirely complete. Also in 1897, the Mississippi Central Railroad began to lay tracks westward from Hattiesburg, and by 1908, the line reached Natchez by absorbing the Natchez and Eastern Railroad. In 1902, a railroad route was also completed between Hattiesburg and Mobile, thus making Hattiesburg the central connection point of railroads in southeast Mississippi.

Sawmills played a large role in the early development of the city. The J.J. Newman Lumber Company, the Tatum Lumber Company, and the Kamper and Buschman Lumber Company were all operating in the city before 1900. The Newman Company, which also owned the Mississippi Central Railroad, had sawmill operations in both in Hattiesburg and in Sumrall, 17 miles west of the city. One of the largest sawmills in the south, the Newman Company employed 2,000 employees in the Hattiesburg and Sumrall operations.

Hattiesburg grew slowly but steadily from 1884 to 1900. One estimate places the number of people in the city at 250 in 1884. By 1890, residents numbered 1,172. After 1900, the growth of the city began to accelerate, and at the dawn of the 20th century, 4,175 people lived in the city. By 1910, the town boasted a population of 11,733 and was the fifth largest city in the state. The trend of growth has continued throughout the 20th century. With more than 44,779 people calling the city of Hattiesburg home, currently it is a metropolitan area with over 110,000 people.

Born of railroads and sawmills, the town also developed as an educational center. South Mississippi College was founded in 1906 and operated under President W.I. Thames until a number of the college's buildings were destroyed by fire. A 1908 advertisement for the college boasted an enrollment of 380 students, with special programs in domestic service, art, expression, and music. The school gained new life in 1911 when W.S.F. Tatum, a prominent local businessman who would later serve as mayor, purchased the property and donated it to the Mississippi Baptist Convention. Reborn as Mississippi Women's College, the institute reopened in 1911 and continued to educate students until 1940, when economic hardship forced the college to close. The facility reopened at the close of World War II and operated again as Mississippi Women's College until 1953. Now known as William Carey College, the school has an enrollment of more than 2,400 students.

In 1910, the state legislature established Mississippi Normal College, which opened on cutover pineland west of the city in 1912 with a student body of nearly 250. Architect R.H. Hunt of Chattanooga designed the five initial buildings of the campus in the Colonial revival style: College Hall, Forrest County Hall, Hattiesburg Hall, The Honor House, and the Alumni House, originally known as the Industrial Cottage. Hunt also prepared the plans for Mississippi Hall, constructed in 1914, and Southern Hall, constructed in 1922. Along with the Administration Building and Bennett Auditorium, both of which opened in 1928 and were designed by Vinson B. Smith Jr., these nine buildings now constitute the University of Southern Mississippi Historic District.

In 1922, the college granted its first baccalaureate degree, and in 1924, the name of the school changed to State Teachers College. Shortly before World War II, the name of the college changed again to Mississippi Southern College, and in 1962 the school gained its current title: The University of Southern Mississippi. Today, known affectionately as "Southern Miss" or simply as "USM," the university sits in the center of Hattiesburg and has a student population of more than 14,000.

Another major influence on the development of Hattiesburg in the 20th century has been the military base located at Camp Shelby, just south of the city. First opened as a federal military base during the First World War, the base was reactivated during World War II and served as a major training camp for the United States Army. From 1941 to 1945, more than 750,000 men received some type of military training at Shelby. Estimates indicate that the number of men stationed at the base at one time exceeded 50,000. Today the base serves as a training facility for National Guard troops and is home to the Mississippi Military Department's Armed Forces Museum. During the summer of 2004, the base was activated to train troops for overseas duty in conjunction with the War on Terror.

During the second half of the 20th century, Hattiesburg expanded westward as new transportation routes such as the Highway 49 Bypass and Interstate 59 created new pathways for the flow of goods and people. By the 1960s, the city of Hattiesburg contained land not only

in Forrest County but in Lamar County as well. Shopping malls, residential neighborhoods, churches, and medical facilities developed in the area west of Highway 49, and the downtown area was no longer the focal point of life in the city. The rapid development of the western section of the city is a process that is still ongoing.

Scholars who study the American city realize change is inevitable. Historic sites will regrettably be lost, landscapes will be altered, and neighborhoods once new will fall into disrepair. Other areas will be born or reborn into new splendor. Historians can only hope to offer snapshots in time to capture the past of the city for future generations and to rekindle the memories of sights and scenes that time has clouded. *Hattiesburg in Vintage Postcards* is a humble attempt to do just that.

One
THE HUB CITY

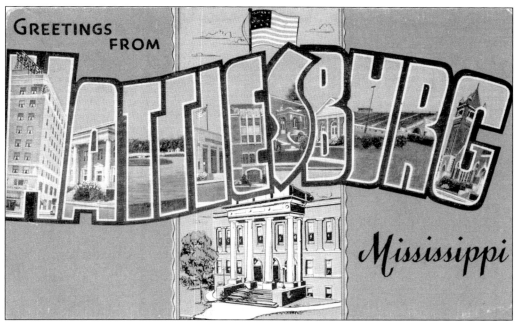

Visitors to the area often sent cards home to relatives, friends, and family as they visited new locales. This postcard bids the recipient "Greetings from Hattiesburg, Mississippi" and features 10 scenes depicting life in the city. The scenes in the letters include the Forrest Hotel, the YMCA on Main Street, Lake View Park, the downtown post office, the "old" Hattiesburg High School, the "old" Public Library, the American Legion Civic Center, the ball stadium and dorm at Mississippi Southern College, and the Main Street Methodist Church. The postcard dates *c*. 1940.

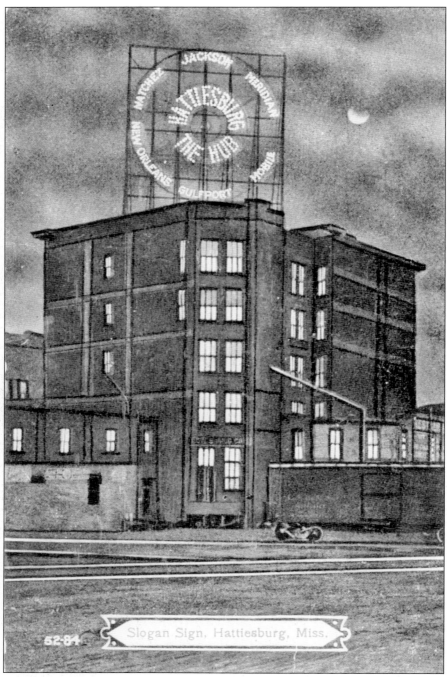

Slogan Sign, Hattiesburg, Miss.

Pictured in this vintage image is the famous Hub City sign, erected in 1912 atop the Ross Building. Positioned so that it could be seen by visitors arriving in town on the railroad, the sign towered 150 feet above the ground and utilized more than 1,100 electric lights. City names listed on the sign included Jackson, Meridian, Mobile, Gulfport, New Orleans, and Natchez. The fate of the sign is uncertain, but it was removed from the building by World War II.

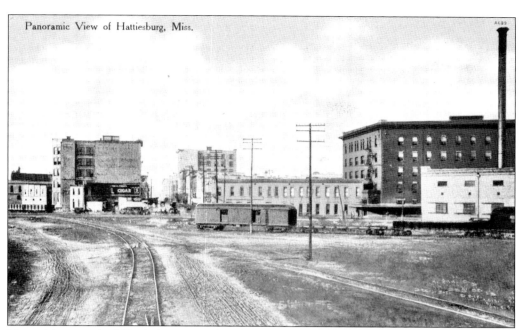

Panoramic View of Hattiesburg, Miss.

Most visitors reached Hattiesburg via railroad during the early part of the 20th century. This view of downtown would be one of the first glimpses of the city proper for many travelers. This image is taken from the New Orleans and Northeastern tracks looking southward toward downtown.

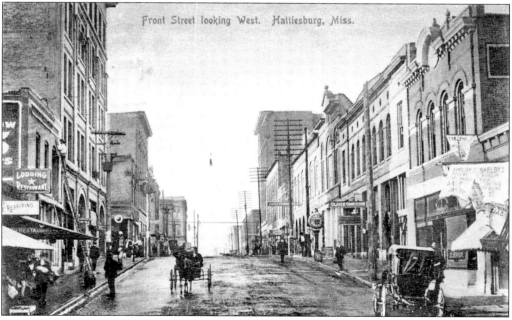

Front Street looking West. Hattiesburg, Miss.

Until roughly 1960, "downtown" was the center of commercial operations in the city. Front Street, due to its proximity to the railroad tracks, was one of the first streets to develop an urban appearance. By the time this postcard was taken, about 1905, the area was well developed and housed a variety of businesses.

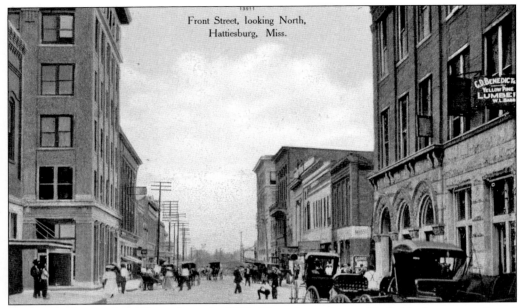

Front Street, looking North,
Hattiesburg, Miss.

This scene shows a busy Front Street in 1909. The primary form of individual transportation at this time was the horse and buggy. Here, a yellow pine lumber dealer has taken advantage of the busy street and its central location to set up shop. By 1910, there were over 30 lumber dealers located in the city.

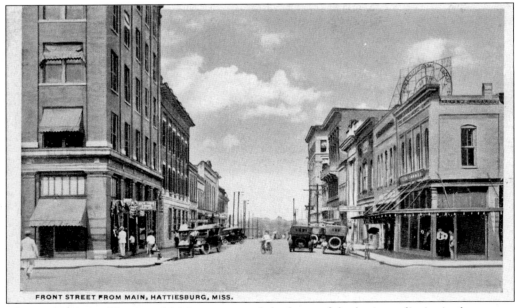

FRONT STREET FROM MAIN, HATTIESBURG, MISS.

The intersection of Front and Main represented the heart of the business district in downtown Hattiesburg. This postcard, taken in the mid-1930s, reflects the fact that the automobile had become an important part of the transportation network. Notice the Hub City sign atop the Ross Building in the background. Its reign over the cityscape would end not long after this image was taken.

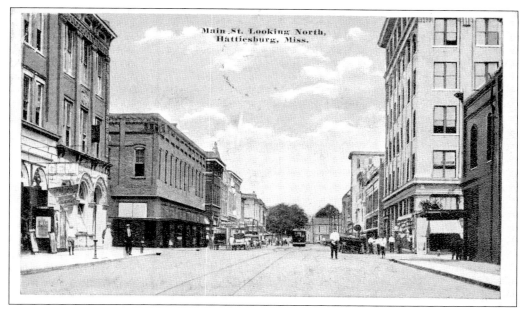

Streetcars of the Hattiesburg Traction Company, such as the one pictured in this 1917 card, carried residents across town from 1907 until 1925, when they were replaced with motorized vehicles. Street car lines reached beyond downtown to the Mississippi Women's College and Mississippi Normal College, both located, at that time, on the edge of town.

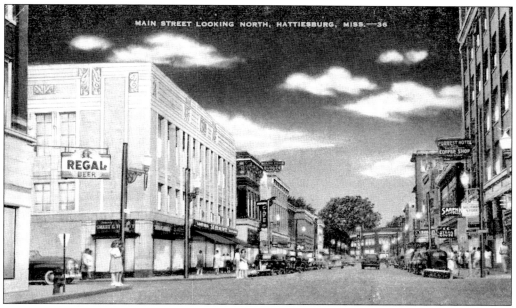

This card features the same view as the one above but dates 20 years later. The streets are filled with shoppers, and parking places are at a premium. Sarphie Jewelers and the K.C. Steakhouse, both well-known Hattiesburg businesses, can be seen on the right. Sears and Roebuck can be seen in the distance.

15

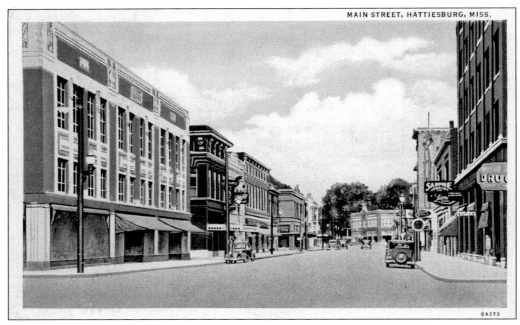

Here is another view of Main Street in Hattiesburg. This card was mailed in 1937. Like many other collectors, the sender hoped for a unique view card in return. Postcard aficionados often used this method to expand their card portfolio. Although the "golden age" of postcard collecting occurred between 1900 and 1917, postcards continue to be popular collectors' items.

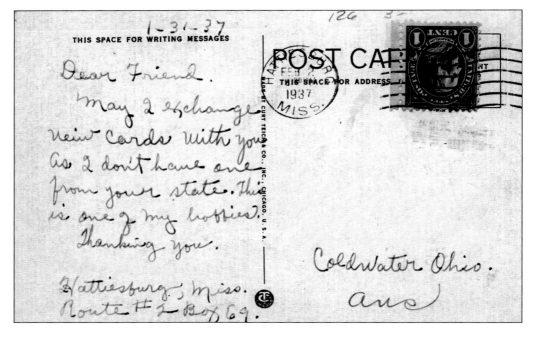

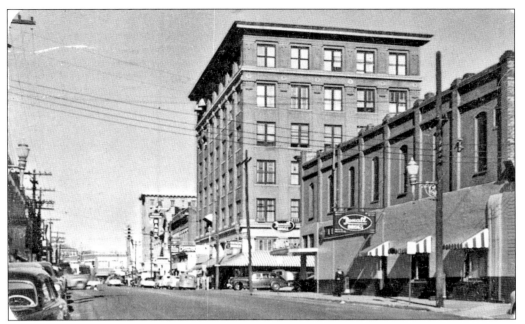

This 1951 view of Main Street can be used to track the changes in transportation and street usage. Notice the large number of automobiles on Main Street. The trolley tracks pictured in earlier postcards of the same scene are no longer extant. The Carter Building is the imposing edifice on the right.

This view looks south on Main Street from the front of the Forrest County Courthouse. The Strickland Furniture Company and Rogers Jeweler can be seen on the right, and Walgreens Drug Store is on the left. The Kress Department Store can be seen just past the bus on the right.

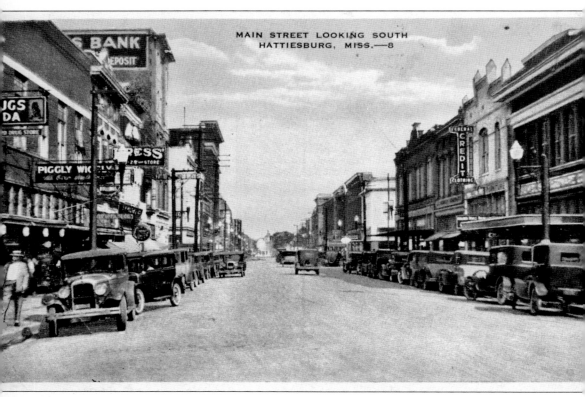

In this view, looking south on Main Street, the local Piggly Wiggly and S.H. Kress stores are clearly visible. Both stores were part of regional chains that came to life during the early decades of the 20th century. S.H. Kress founded his first store in Memphis in 1896, and by the time of his death in 1955, he operated 264 stores across the nation. His theory of high volume and low prices set the standard for later 20th-century retailers. In 1916, entrepreneur Clarence Saunders opened his first Piggly Wiggly in Memphis, Tennessee. This grocery store allowed shoppers to choose the items directly from the store's shelves, as opposed to the method in place at the time that required patrons to present a list of items to a clerk. By the 1920s, hundreds of Piggly Wiggly franchise stores were in operation across the southeast, including this one on Main Street in Hattiesburg.

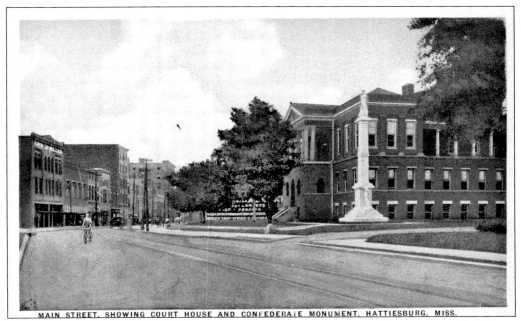

MAIN STREET, SHOWING COURT HOUSE AND CONFEDERATE MONUMENT, HATTIESBURG, MISS.

Until 1906, Hattiesburg was part of Perry County. In that year, the Mississippi legislature authorized the creation of Forrest County. The county government took office in 1908. Constructed in 1905, the Forrest County Courthouse represents the neo-classical revival style of architecture. The courthouse has been remodeled several times, the first time in 1922.

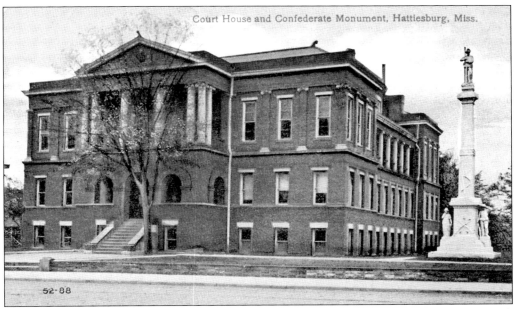

Court House and Confederate Monument, Hattiesburg, Miss.

52-88

The Confederate Monument was erected adjacent to the courthouse in 1910 in conjunction with a reunion of Confederate Veterans. The Hattiesburg chapter of the United Daughters of the Confederacy played a major role in the creation of the monument. The group was also instrumental in the creation of Kamper Park.

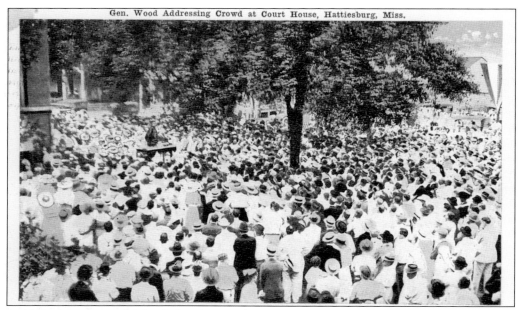

Gen. Wood Addressing Crowd at Court House, Hattiesburg, Miss.

In 1917, Gen. Leonard Wood visited Hattiesburg to tour a proposed site for a new military base south of the town. New bases were being established across the nation to train troops for World War I. Shortly after Wood's visit, the announcement came that the army would establish the military training facility known today as Camp Shelby.

During 1964, the Forrest County Courthouse was the focal point of the local Civil Rights movement. Beginning in January 1964, African Americans picketed regularly outside of the building in protest of county officials' choice not to register black voters. Today, the courthouse is one of 15 sites on the Freedom Summer Trail, which highlights historical locations from the Civil Rights movement in Hattiesburg.

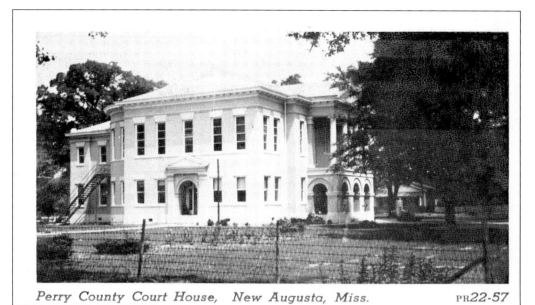

Perry County Court House, New Augusta, Miss. PR22-57

Forrest County was organized from the western half of Perry County in 1908. Perry County, formed in 1820, was named after Oliver Hazard Perry, a naval hero of the War of 1812. Although the county seat was first at Augusta, this postcard depicts the new courthouse constructed in New Augusta.

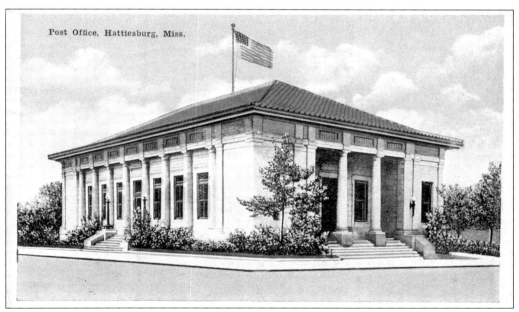

Post Office, Hattiesburg, Miss.

Known today as the "Old Federal Courthouse," this building was the first in Hattiesburg to be added to the National Register of Historic Places. Designed by architect John Taylor Knox, the building was constructed as a post office in 1910 and continued to be used as such until 1934. After that time, it served as a federal office building and housed the federal district court from 1939 until the construction of the Colmer Building in the early 1970s.

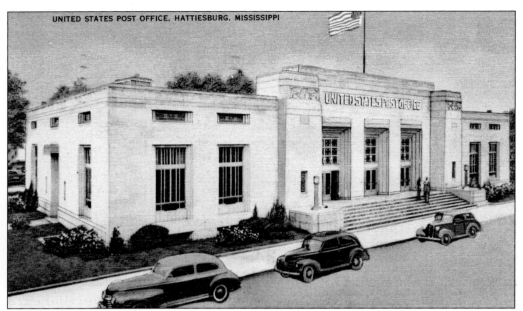

The local postal facility was often depicted on postcards. This card depicts the Hattiesburg Post Office as it appeared in 1941. The message on the address side of the postcard notes that the visitor is "seeing some new territory this week. Expect to go back to Shreveport this weekend."

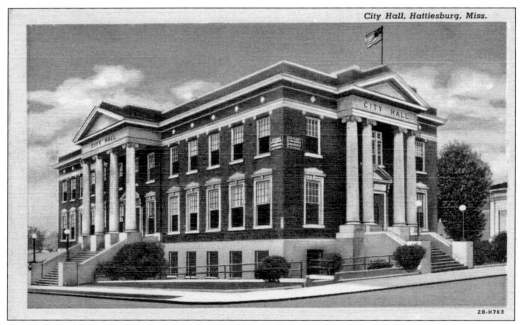

Opened in 1923, the Hattiesburg City Hall was designed in the neo-classical revival style by Hattiesburg architect Robert E. Lee. One of the area's most renowned architects, Lee studied as the understudy of architect Gustave Torgerson in Meridian before setting up his own practice in Hattiesburg. According to the verso of the card, the facility also housed the mayor's office, the main fire department, and the police department.

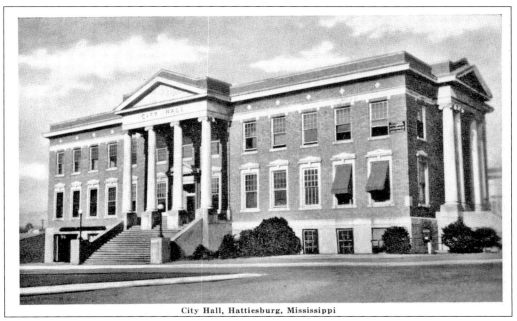

City Hall, Hattiesburg, Mississippi

Here is another view of Hattiesburg's city hall. Despite renovations in 1962 and from 1980 to 1981, the building earned designation at a Mississippi Landmark in 1988. One of the building's defining features was the two porticos featuring four Ionic columns. Sadly, the Front Street portico was enclosed during the 1962 renovation.

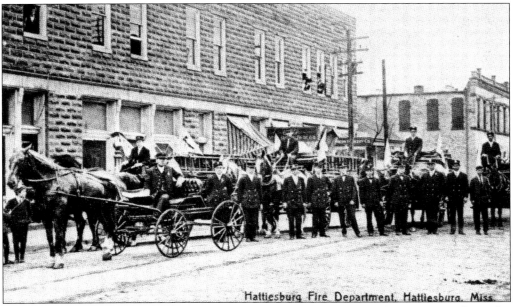

Hattiesburg Fire Department, Hattiesburg, Miss.

Until 1904, Hattiesburg was served by a volunteer fire department. In that year, a paid city fire department was organized with A.F. Potter at the helm. This 1909 postcard depicts the department as it appeared at that time.

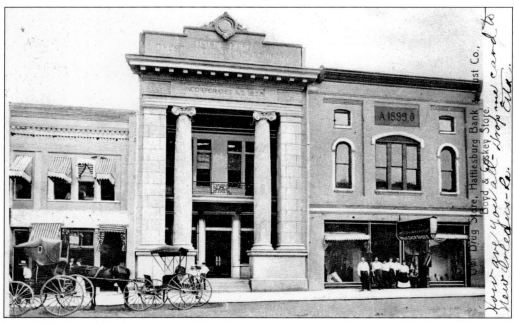

Pictured in this early vintage postcard are the Owl Drug Store, Hattiesburg Bank and Trust, and the Boyd and Coskey Store. Located at 111 East Front Street, the Bank of Hattiesburg listed capital of $50,000 and deposits of more than $875,000 in 1918. It was one of three banking facilities located in Hattiesburg at the time. The adjacent Owl Drug Store published many of the early view postcards of Hattiesburg. The employees of Boyd and Coskey are lined up in front of the store to be included in the picture.

The former Hattiesburg Bank and Trust Building is pictured in 2004.

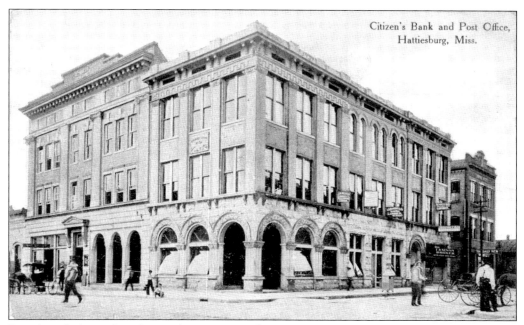

Citizen's Bank and Post Office,
Hattiesburg, Miss.

Prominently located at the southeast corner of Main and Front Streets, the Citizens Bank was one of three early banking institutions in Hattiesburg. The importance of yellow pine lumber in the city economy is evident, as no fewer than four signs advertise the services of lumber dealers. Also featured in this view are the Kennedy Building and the offices of the *Daily News*.

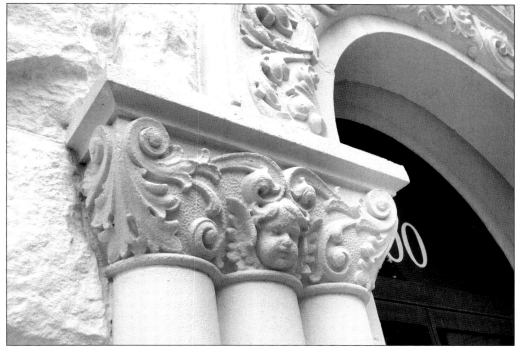

This close-up shows the scrollwork located on the arches of the above building, *c.* 2004.

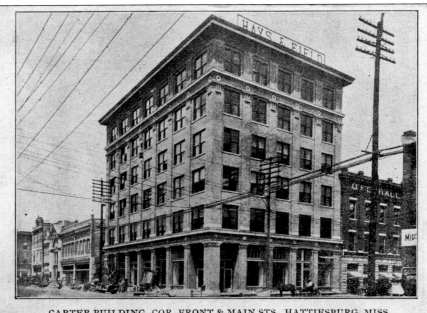

CARTER BUILDING, COR. FRONT & MAIN STS., HATTIESBURG, MISS.

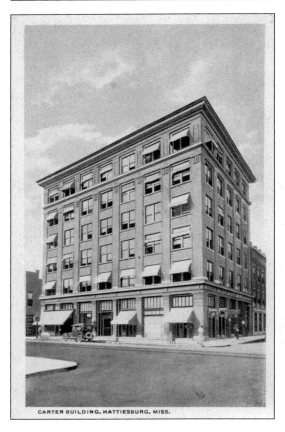

CARTER BUILDING, HATTIESBURG, MISS.

The six-story Carter Building was one of the first "skyscrapers" in Hattiesburg. The address side of this card, mailed in 1907, tells of an incident with the building's elevator: "Elevator fall in this building today from 6th Floor. Three men badly hurt." O'Ferrall's can also be seen to the right of the Carter Building on Front Street. The Carter Building was named in honor of John Prentiss Carter, a Hattiesburg lawyer and politician who served as lieutenant governor of the state from 1904 to 1908.

Later, the Carter Building was renamed the Faulkner Building after Lewis Edward Faulkner, longtime Hattiesburg businessman and owner of Faulkner Concrete. In early 2004, renovation work began on the building to return the first-floor exterior to its original appearance.

This early postcard depicts the Ross Building, constructed in 1907, as it looked before the placement of the Hub City sign on its roof in 1912. The building was owned and named for Dr. T.E. Ross, an early Hattiesburg physician. The Ross Building in later years was called the Royal St. Andre Hotel and the America Building.

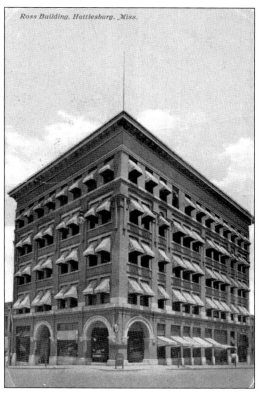

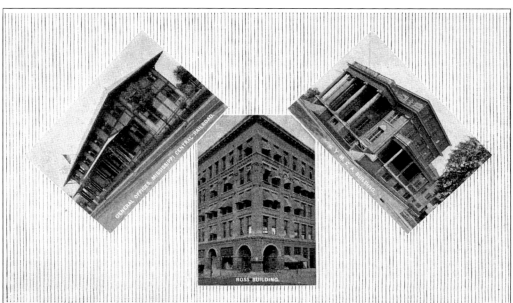

This vintage view of Hattiesburg highlights three historic Hattiesburg structures. The general offices of the Mississippi Central Railroad were located on Bouie Street, the Ross Building on East Front Street, and the YMCA building on Main Street.

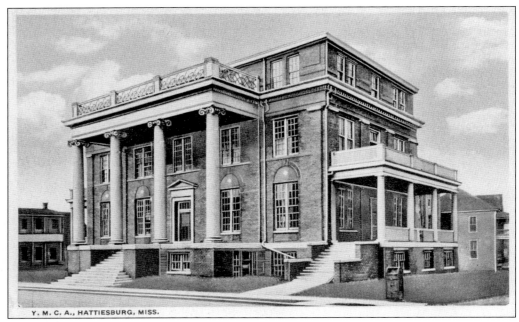

Y. M. C. A., HATTIESBURG, MISS.

Although construction began on the Hattiesburg YMCA in 1914, the building was not completed until 1918. It was located on Main Street near where the Colmer Federal Building stands today. The building served the city until the mid-1950s, when it was sold to finance a new building on Hutchinson Avenue near the site of the current Hattiesburg High School.

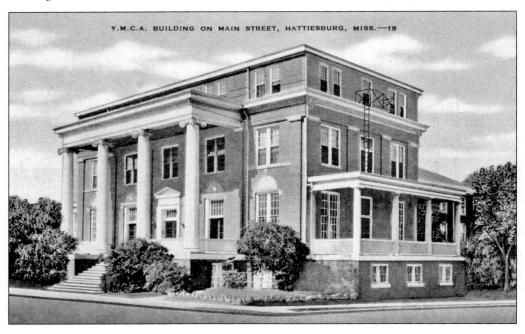

Y.M.C.A. BUILDING ON MAIN STREET, HATTIESBURG, MISS.—19

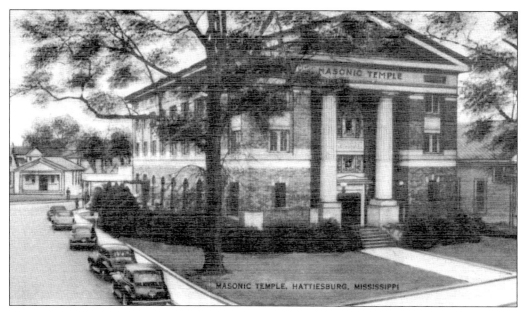

Hattiesburg's Masonic Lodge, located at 700 Main Street, opened in 1920. The neo-classical revival style building was designed by Hattiesburg architect Robert E. Lee. The building functioned as a Masonic Lodge from 1920 until 2003, when it was acquired by the City of Hattiesburg. The structure is listed on the National Register of Historic Places as part of the Hub City Historic District.

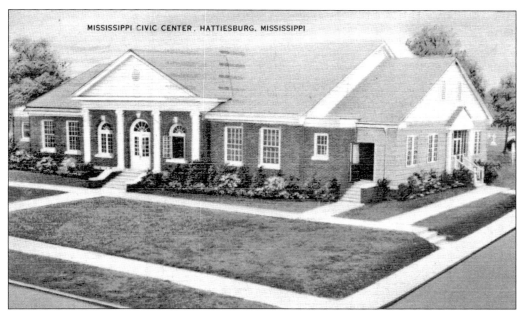

The American Legion Civic Center is pictured in this card, *c.* 1940. The center, located on Green Street, was a favorite with soldiers from Camp Shelby during World War II. Throughout the war, dances were held twice a week at the facility, with square dances on Tuesday and round dances on Saturday.

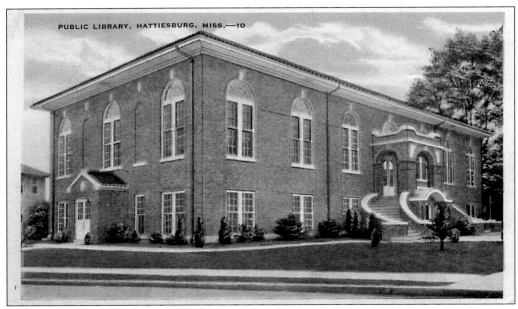

In 1928, a referendum authorized the building of a new public library in Hattiesburg. The library was built on Main Street on land purchased from the First Presbyterian Church. The official dedication of the library was on May 22, 1930. During the 1930s, the library hosted a series of public forum speakers including noted historian Bell Wiley, former Mississippi Normal College professor and author of the Civil War classics *Johnny Reb* and *Billy Yank*.

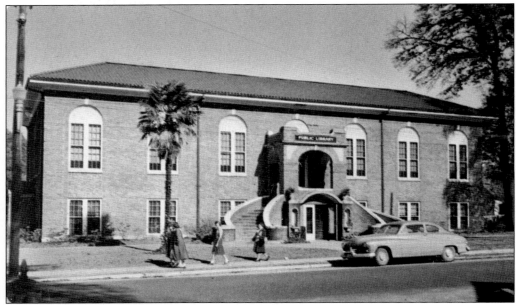

Designed in the Renaissance revival style, this building served the City of Hattiesburg until 1996 when a new, modern facility opened on Hardy Street. The building is now used as a cultural center. It is currently one of 15 sites that can be visited on the Freedom Summer Trail in Hattiesburg.

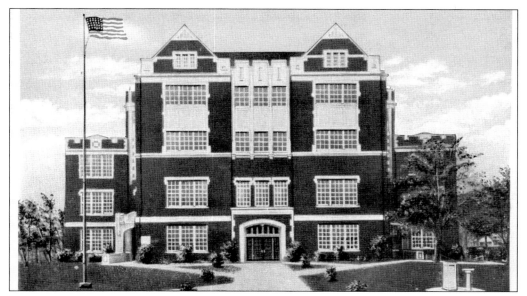

Like several other Hattiesburg buildings of the early 20th century, the "old" Hattiesburg High School was designed by local architect Robert E. Lee. The school was constructed in two phases: the rear in 1911 and the front in 1921. The building represents a departure in style for Lee, who designed the edifice in the Jacobethan style.

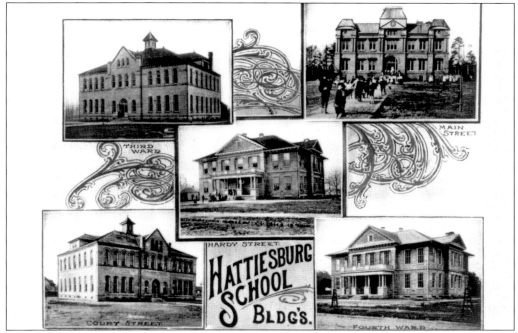

Five early Hattiesburg school buildings are featured on this vintage card. They include the following: The Third Ward School, Main Street School, Hardy Street School, Court Street School, and the Fourth Ward School. (Image courtesy Mississippi Department of Archives and History.)

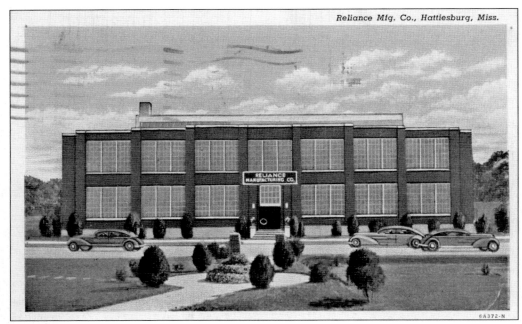

Reliance Mfg. Co., Hattiesburg, Miss.

Hattiesburg's two-story Reliance Manufacturing Company is pictured in this view card, *c.* 1941. Despite the downturn of the Depression, Reliance was able to open a new shirt producing facility in the Hub City in 1933. By 1936, the company had invested $400,000 in the Hattiesburg facility, and the operation employed 350 people.

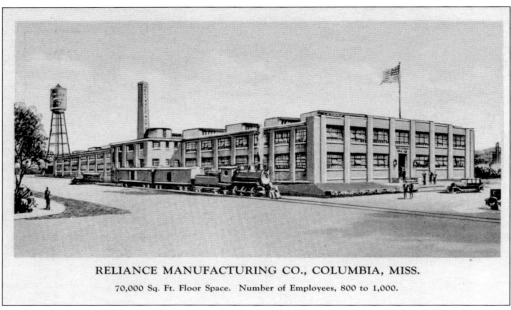

RELIANCE MANUFACTURING CO., COLUMBIA, MISS.

70,000 Sq. Ft. Floor Space. Number of Employees, 800 to 1,000.

In 1932, before building in Hattiesburg, Reliance Manufacturing erected a large plant in nearby Columbia, Mississippi. Columbia mayor Hugh White was instrumental in bringing the facility to the town. White would go on to serve two terms as governor of Mississippi. By 1936, the plant boasted 1,000 employees.

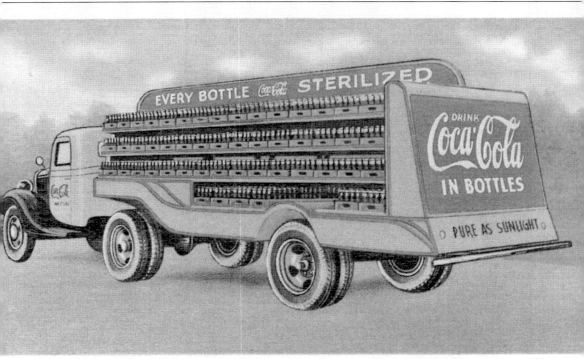

WELDMECH *FULL STREAMLINE* **BOTTLERS' SEMI-TRAILER BODY**
Capacities 180 to 325 Cases or More

5A-H170

Invented in 1886 by John S. Pemberton, the consumption of Coca-Cola matured into a national pastime by 1930. Bottlers across the nation were taking advantage of the American love affair with soda by selling the drink in glass containers in a variety of retail stores. This distinctive advertising postcard features a unique method of getting the product to market, a special trailer body designed to carry bottled soda. The trailers were manufactured by the Weldmech Steel Products Company of Hattiesburg. According to the card, the trailer body offered a "Sign box built-in for carrying road signs-rear bumper-torpedo type running boards and one piece pressed steel drop panels."

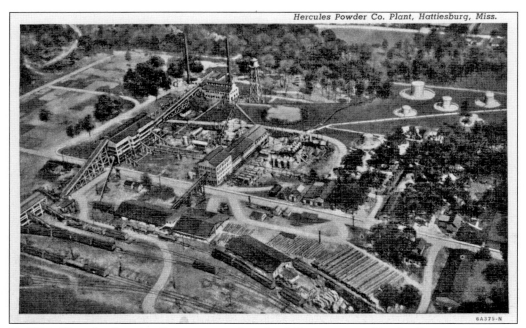

In 1920, Hercules Powder Company purchased a 100-acre tract of land adjacent to both the Mississippi Central Railroad and the Gulf and Ship Island Railroad on which to build a naval stores plant. The Hattiesburg plant opened in 1923 and is still in operation today. Above is an aerial view of the plant, c. 1930.

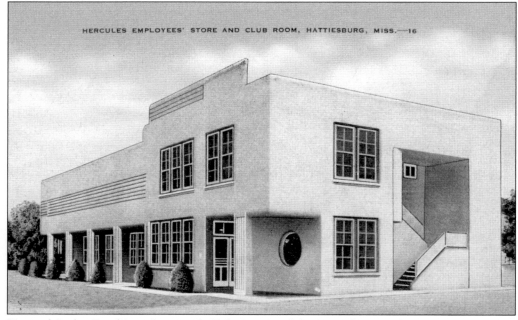

HERCULES EMPLOYEES' STORE AND CLUB ROOM, HATTIESBURG, MISS.—16

Pictured is the Employee Store and Club Room of the Hercules Powder Company plant in Hattiesburg, Mississippi, c. 1930.

34

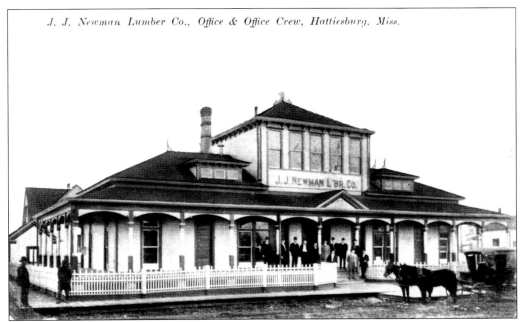

J. J. Newman Lumber Co., Office & Office Crew, Hattiesburg, Miss.

In 1894, Judson Jones Newman established a sawmill operation in Hattiesburg. For the next 49 years, this company would have a major impact on the economy of not only the city of Hattiesburg, but also the entire region. Sadly, Newman would not live to see the success of the company that carried his name, as he died in 1900. (Image courtesy Mississippi Department of Archives and History.)

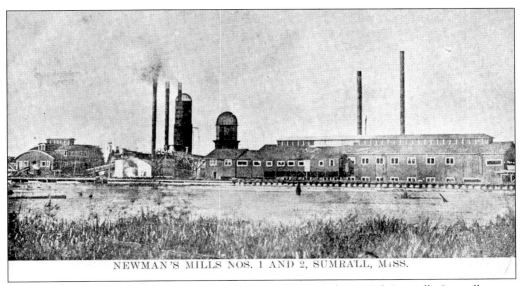

NEWMAN'S MILLS NOS. 1 AND 2, SUMRALL, MISS.

The J.J. Newman Company operated mills in both Hattiesburg and Sumrall. Sumrall was a company town some 17 miles west of the Hub City on the Mississippi Central Railroad. With the arrival of the railroad in 1902, the town grew quickly and was incorporated in 1903. This 1907 view card shows the Newman Number One and Number Two mills in Sumrall. Neither mill stands today.

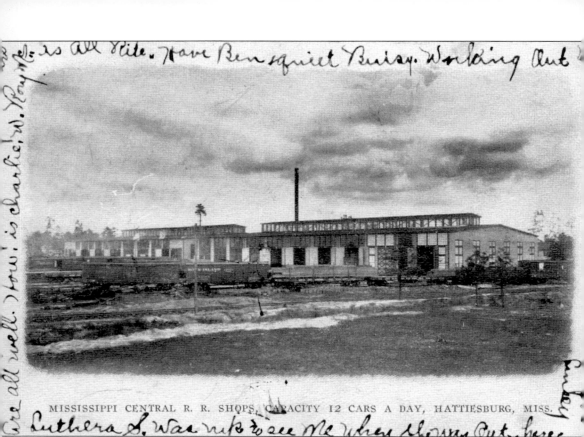

MISSISSIPPI CENTRAL R. R. SHOPS, CAPACITY 12 CARS A DAY, HATTIESBURG, MISS.

The Newman Company also controlled the Mississippi Central Railroad, which extended from Hattiesburg westward to Natchez. First organized as the Pearl and Leaf River Railroad in 1897, the line laid tracks westward through the timber rich lands west of Hattiesburg. By 1905, the line had reached Brookhaven, and the name of the railroad was changed to the Mississippi Central. After absorbing the Natchez and Eastern Railway in 1908, the route to Natchez was complete. The general offices of the railroad were located on Bouie Street in Hattiesburg, while the freight depot was at the corner of New Orleans and Second Streets. By 1910, two trains departed Hattiesburg daily for points west. This 1909 card shows rail cars lined up at the Mississippi Central Shop.

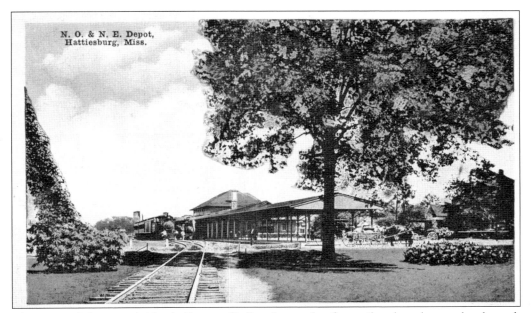

The New Orleans and North Eastern Railroad was the first railroad to lay tracks through Hattiesburg. A vision of Capt. William Harris Hardy, the route connected New Orleans with Meridian. The first trains ran between the two cities in 1883. This view looks north toward the New Orleans and Northeastern Depot, constructed in 1910.

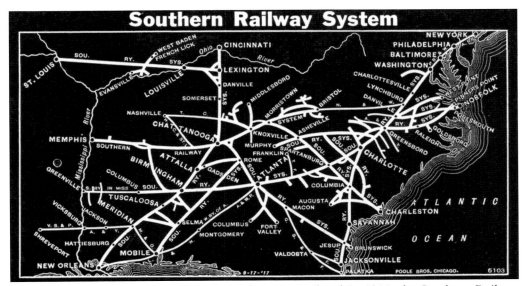

After absorbing the New Orleans and Northeastern Railroad in 1916, the Southern Railway network connected Hattiesburg with New Orleans, Atlanta, and the Eastern Seaboard. Amtrak passenger trains still service Hattiesburg today along the same route.

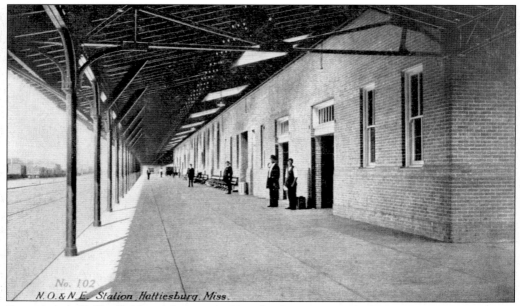

No. 102
N.O.&N.E. Station, Hattiesburg, Miss.

Passengers and rail officials can be seen waiting for the next train in this early view card. During the 1920s, the station was serviced by eight trains daily, four traveling north and four traveling south. Passengers arriving at the depot had to change trains to reach Natchez, Gulfport, Jackson, or Mobile via other railroad lines.

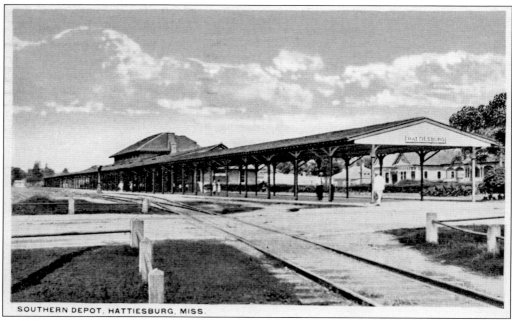

SOUTHERN DEPOT, HATTIESBURG, MISS.

Mailed in 1921, this view card reflects the name change of the New Orleans and Northeastern Railroad to the Southern Railway System. With a decline in railroad use, the depot fell into disrepair during the latter half of the 20th century. Today, the depot is undergoing major renovations into an inter-modal transportation facility.

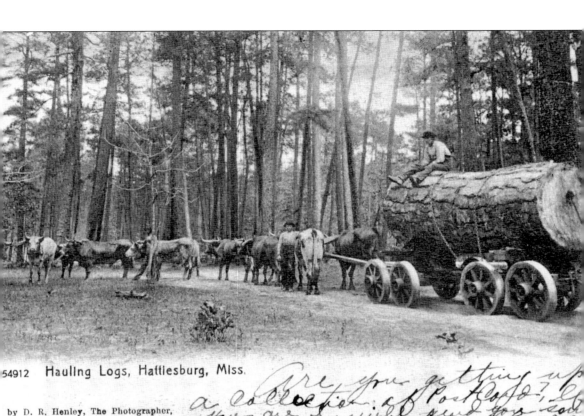

54912 Hauling Logs, Hattiesburg, Miss.

by D. R. Henley, The Photographer,

Are you getting up a collection of postcards? If you are I will send you some every week . . .

Trees in the pine forests of south Mississippi could reach 150 feet in height and 9 feet in diameter, as evidenced by the large pine featured in this 1907 postcard. The log is mammoth in size compared to the man sitting atop it. The scene also reveals the towering pines and scant undergrowth that characterized south Mississippi at the time. Because of the plentiful pines, the region early on was labeled the "piney woods." The receiver may have been bitten by the postcard bug, as the sender asks, "Are you getting up a collection of postcards? If you are I will send you some every week . . ."

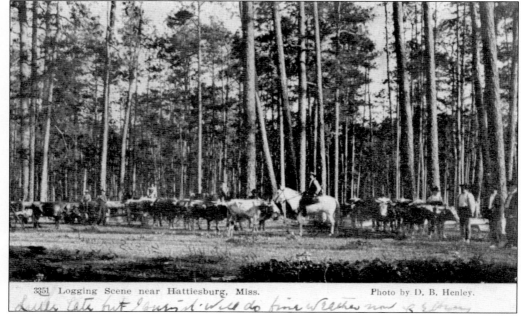

3351 Logging Scene near Hattiesburg, Miss. Photo by D. B. Henley.

[handwritten note]

After timber was felled, oxen were often used to pull the timber to the dummy line or main railway. Dummy lines were temporary rail tracks laid into the woods to accommodate timber removal. This 1906 card shows two oxen teams at work; steam skidders were also sometimes used to retrieve the logs.

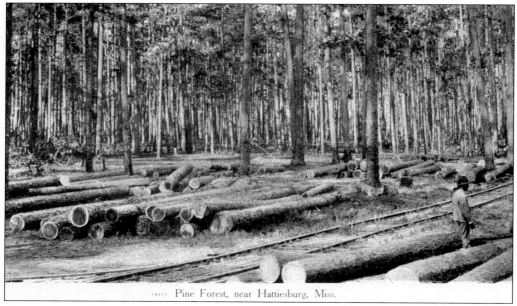

Pine Forest, near Hattiesburg, Miss.

The most prized pine in the South was the longleaf. Longleaf pine grew in a narrow belt of Mississippi stretching from the Gulf Coast inward some 100 to 120 miles. Hattiesburg, like many piney woods towns, was a center of longleaf lumbering activity. In this image, cut lumber is waiting to be loaded on rail cars.

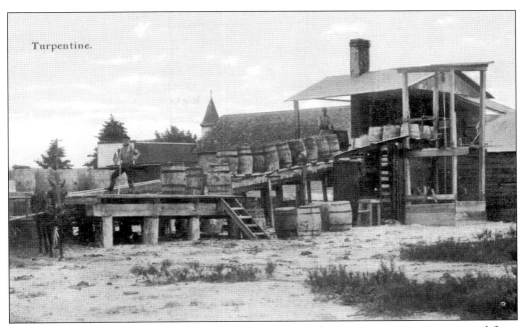

Turpentine.

Cut timber was not the only product of the longleaf pine forest. Turpentine was extracted from pine trees by cutting wedge-shaped notches into the trunks of the trees. The height of the cut varied but was usually four to six feet from the ground. The liquid gum was collected in clay or tin cups as it oozed from the cuts. The cups were emptied into barrels and sent to a still, like the ones pictured here, and distilled into turpentine. Rosin was a by-product of this process.

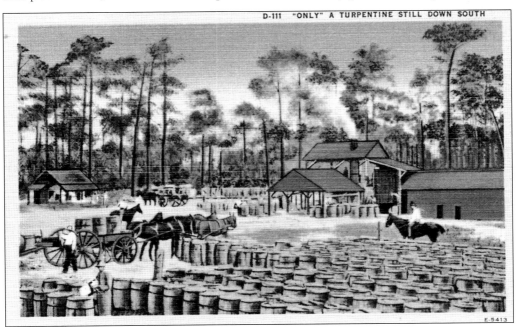

D-111 "ONLY" A TURPENTINE STILL DOWN SOUTH

E-5413

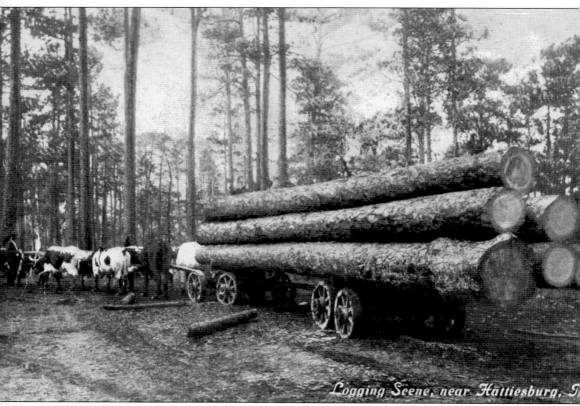

Logging Scene, near Hattiesburg, S.

Eight-wheeled wagons, such as the one pictured here, were patented in 1899 and manufactured by the Lindsey Wagon Company of Laurel, Mississippi. By 1901, the company was the largest manufacturing company in Mississippi. The Laurel plant had a capacity of four Lindsey Wagons per day. Brothers John and S.W. Lindsey were both executives of the company, which not only manufactured wagons for the timber industry, but for use in World War I as well. Properly loaded, they were capable of carrying 20,000 pounds and greatly enhanced the lumberman's ability to move large logs over uneven and sometimes boggy terrain. The last wagon was manufactured by Lindsey in 1964.

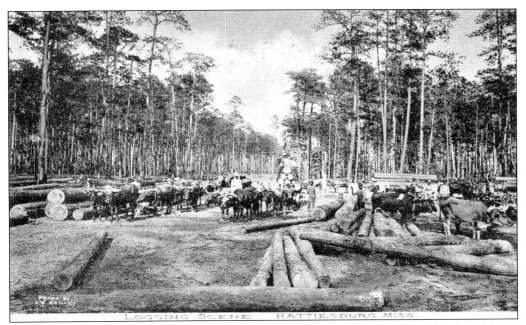

In this 1908 D.B. Henley postcard, African-American teamsters are pulling in cut lumber. African Americans often held the most dangerous jobs in the timber industry and were frequently paid less than their white counterparts. The message on the reverse side reads, "This is the way they do logging in Mississippi."

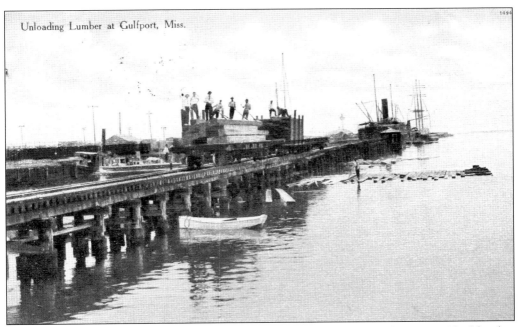

Timber cut in the pine forests of south Mississippi was sent to mills for planing. Finished lumber was then transported to market. Gulfport was a prime transfer point, as lumber could be unloaded from trains and placed aboard oceangoing vessels easily.

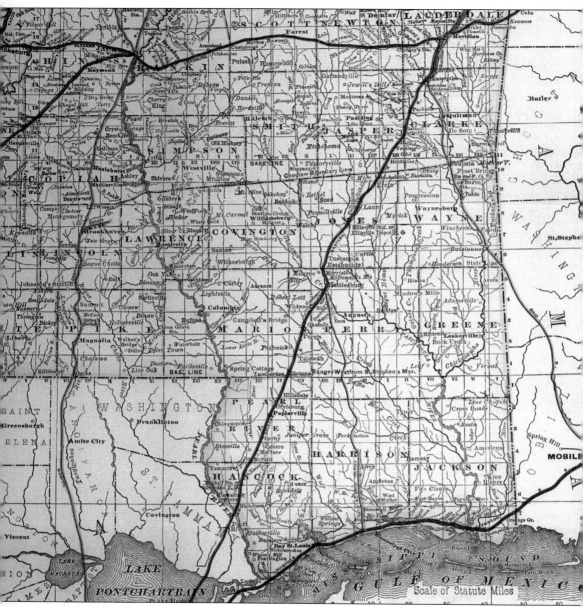

At the beginning of the 20th century, the major form of transportation in Mississippi was the railroad, as evidenced by this 1888 Railroad Commissioners Map. Although railroads would eventually connect Hattiesburg to Jackson, Mobile, and Natchez, at this time, only the New Orleans and Northeastern and a portion of the Gulf and Ship Island Railroad had been constructed. Both the New Orleans and Northeastern and the Gulf and Ship Island Railroads were at one time under the direction of Capt. William Harris Hardy, founder of the piney woods towns of Hattiesburg, Laurel, and Gulfport. The Gulf and Ship Island was eventually finished under the direction of Joseph Thomas Jones of Buffalo, New York. Hardy and Jones are, in large part, responsible for the growth and development of Hattiesburg, although Hardy only lived in Hattiesburg for a brief period, and Jones never did.

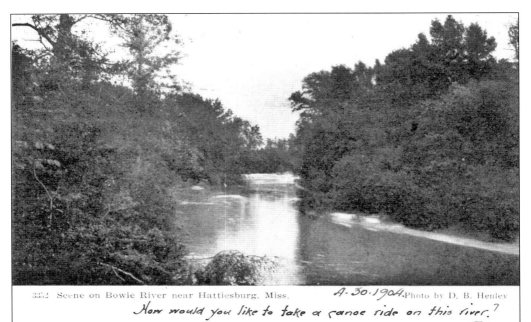

352 Scene on Bowie River near Hattiesburg, Miss. *A-30-1904.* Photo by D. B. Henley

How would you like to take a canoe ride on this river.?

Rob't.

Although Hattiesburg was mainly a railroad town, it was also situated near the confluence of two important piney woods waterways, the Leaf and Bouie Rivers. Flowing southward, the Leaf River joins the Chickasawhay River at Merrill, Mississippi, to form the Pascagoula River. Hattiesburg photographer D.B. Henley captured this view of the Bouie River in 1904.

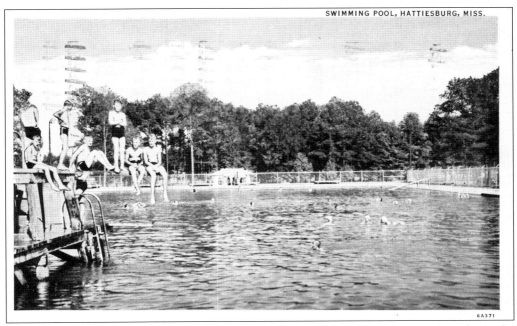

SWIMMING POOL, HATTIESBURG, MISS.

6A371

These local boys discovered a great way to escape the sweltering summer heat: take a dip in the nearest pool!

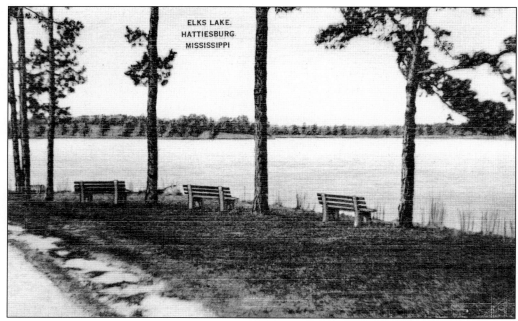

Elk's Lake is located south of Hattiesburg on Elk's Lake Road. The card above depicts Elk's Lake Park, *c.* 1940.

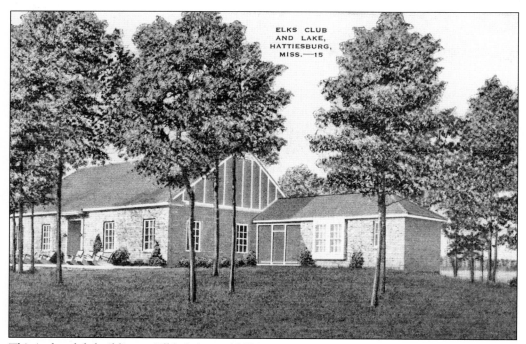

This is the club building at Elk's Lake, *c.* 1940.

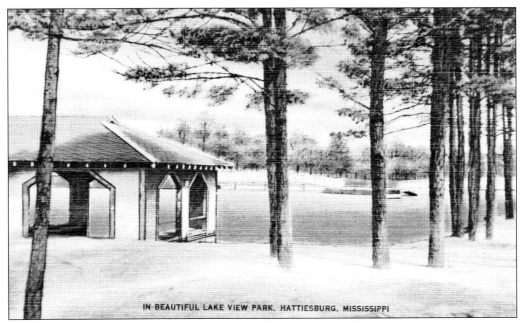

IN BEAUTIFUL LAKE VIEW PARK, HATTIESBURG, MISSISSIPPI

Lake View Park was constructed using funds allocated by the Works Progress Administration during the mid-1930s. Utilized by the public for recreation, the park featured covered picnic areas, arched bridges, and a large swimming pool.

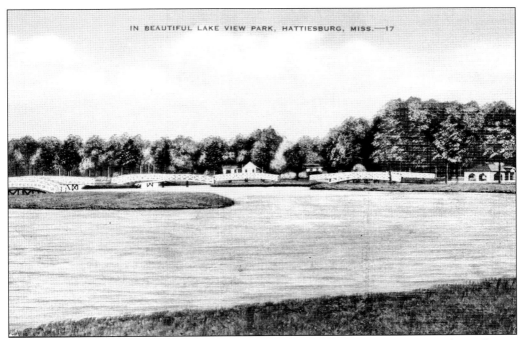

IN BEAUTIFUL LAKE VIEW PARK, HATTIESBURG, MISS.—17

Here is another view of Lake View Park, this one from opposite the above image. The walkways and gazebo in the top image can be seen across the lake.

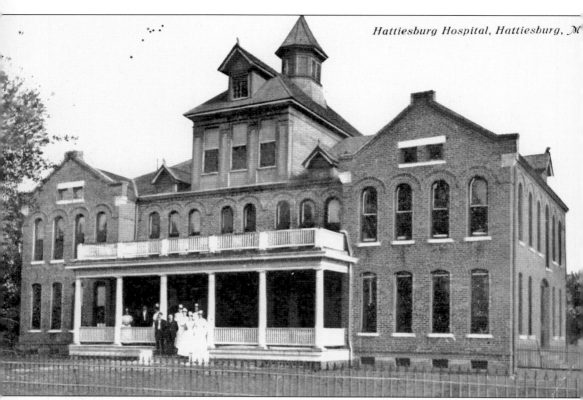

The first hospital in the city of Hattiesburg opened in 1900 under the direction of Dr. Theophilus Erskine Ross. Ross was also involved in a variety of business operations in the city, including serving on the board of directors of the First National Bank of Hattiesburg and as vice-president of Hattiesburg Compress Company. Opening his medical practice in the city in 1892, the early Ross Sanitarium was simply an addition to Dr. Ross's medical offices. In October of 1903, the facility pictured above opened on Bay Street in Hattiesburg with a capacity of 40 beds. Dr. Ross entered into a contract with the Gulf and Ship Island Railroad for the care of its employees, and upon relocation to the new site, the facility took on the name of Gulf and Ship Island Railroad Employees Hospital. Some of the employees have gathered outside the facility to have their photograph taken for this card, mailed in 1913.

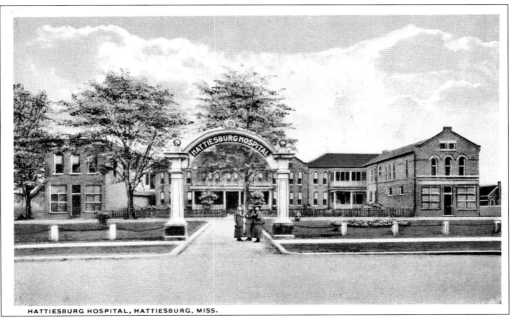

HATTIESBURG HOSPITAL, HATTIESBURG, MISS.

By 1906, the Gulf and Ship Island Employees Hospital, located on Bay Street, also boasted a training school for nurses. In 1908, the name of the facility changed to Hattiesburg Hospital.

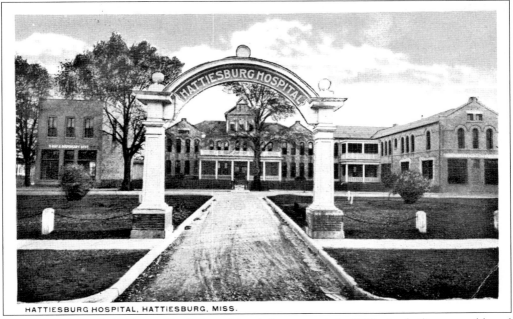

HATTIESBURG HOSPITAL, HATTIESBURG, MISS.

From 1908 through 1918, the Hattiesburg Hospital prospered. In 1918, the facility was sold, and the name changed to King's Daughters Hospital. At this time, the facility enlarged its capacity from 40 to 60 beds. The final and last name change of the facility would occur in 1921, when the facility was renamed the Methodist Hospital.

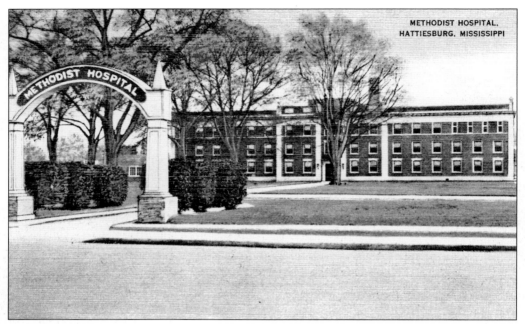

METHODIST HOSPITAL.
HATTIESBURG. MISSISSIPPI

In 1921, the Mississippi Annual Conference of the Methodist Church assumed control of the then-named King's Daughters Hospital. Construction of additional facilities was begun, and in 1926, the hospital added more beds and a nurses' dormitory. Methodist Hospital would operate on the same site until 1980, when the hospital moved to a new facility on Highway 98 West.

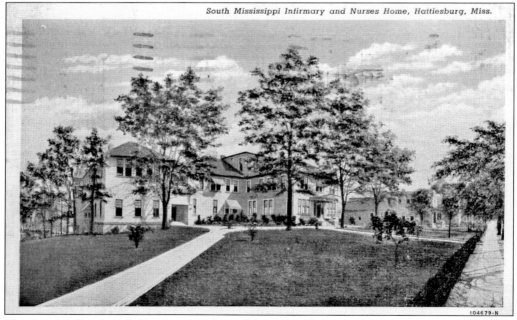

South Mississippi Infirmary and Nurses Home, Hattiesburg, Miss.

104679-N

The South Mississippi Infirmary and Nurses Home was the second hospital to call Hattiesburg home. The original facility was owned by Dr. W.W. Crawford, Dr. C.W. Bufkin, and Dr. J.D. Donald. The building on this card is the later Walnut Street location.

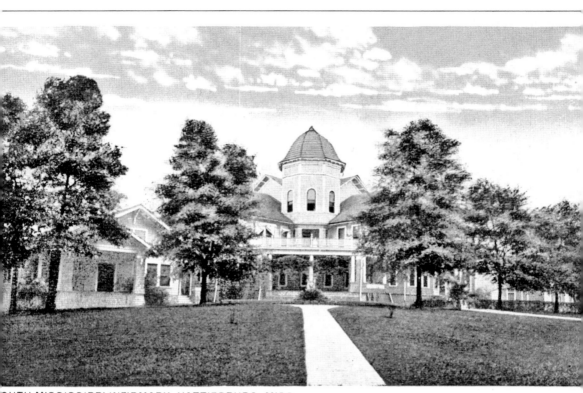

SOUTH MISSISSIPPI INFIRMARY, HATTIESBURG, MISS.

The first South Mississippi Infirmary and Nurses Home was located on Plum Street in Hattiesburg. In 1904, fire destroyed the Plum Street facility, which was rebuilt and promptly burned again. Not giving in to adversity, Dr. W.W. Crawford, owner of the hospital, built a new structure on Walnut Street in Hattiesburg. This facility opened in May of 1905. The hospital served the area until 1956, when the infirmary ceased operation. It was later demolished.

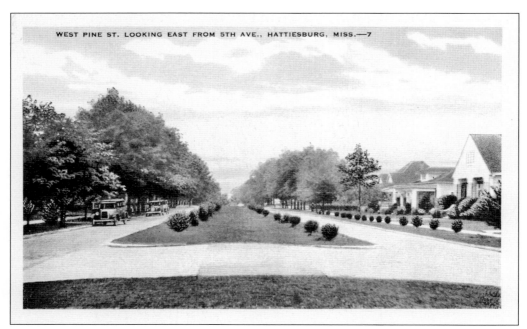

West Pine Street, with its broad median, is pictured in this early postcard.

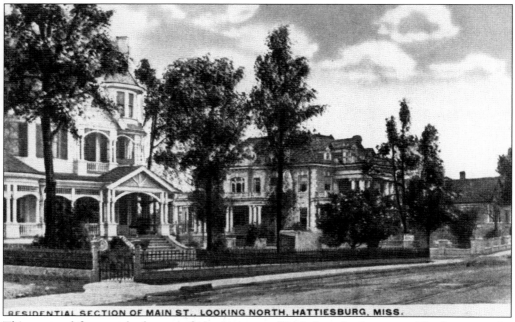

This postcard features the homes of two important Hattiesburg businessmen. The home on the left is the McLeod home. John A. McLeod operated mercantile stores in Hattiesburg from 1896 until the mid-1930s and served as president of Citizens Bank from 1902 until 1924. The McLeod house was built in 1897 in the Queen Anne style. The home on the right was the residence of W.S.F. Tatum, mayor of Hattiesburg from 1922 to 1925 and 1929 to 1937 and the owner of Tatum Lumber Company.

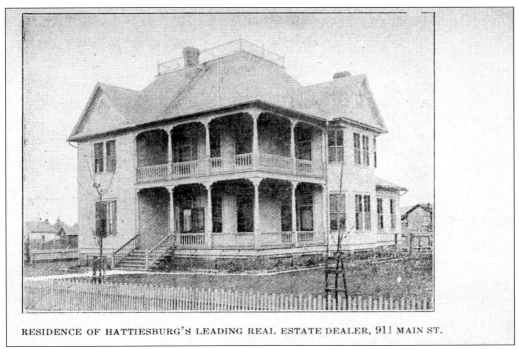

RESIDENCE OF HATTIESBURG'S LEADING REAL ESTATE DEALER, 911 MAIN ST.

Located on North Main Street, this home at address 911 belonged to Thomas M. Ferguson, a local realtor.

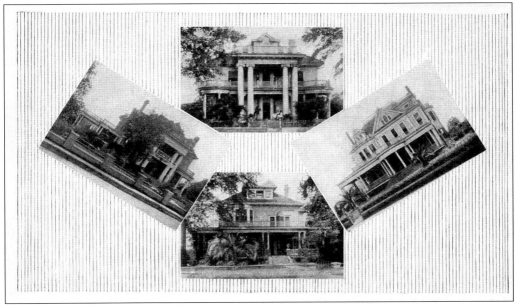

This collage of Hattiesburg homes was published in a Southern Railroad postcard folder, *c.* 1920.

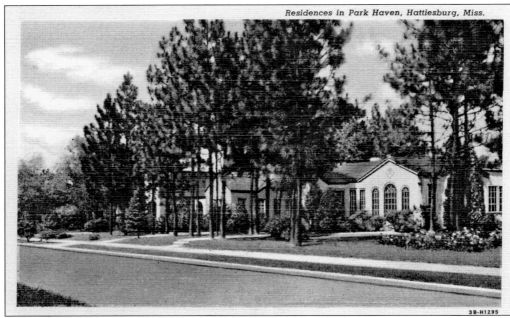

Residences in Park Haven, Hattiesburg, Miss.

3B-H1295

The residential development of Parkhaven occurred in the 1920s. Then on the edge of town, the neighborhood centered on South Twenty-first and South Twenty-second Avenues between Hardy Street on the north and Mamie Street on the south. Although the arched entrance to the subdivision on Twenty-second Avenue has long been a Hattiesburg landmark in its own right, in was not until 2002 that the Parkhaven Historic District received National Register of Historic Places status. In particular, Parkhaven contains 14 homes of Spanish-eclectic design, a rare residential architectural style in Mississippi.

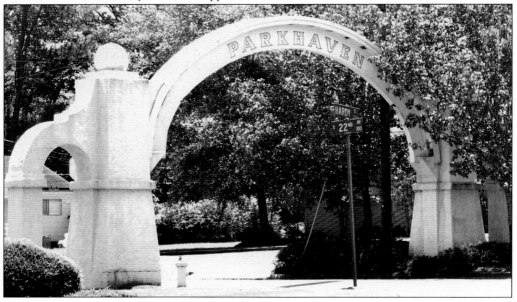

The entrance to the Parkhaven subdivision is marked by an archway. This image of the arch is from 2004.

54

Two
CHURCHES

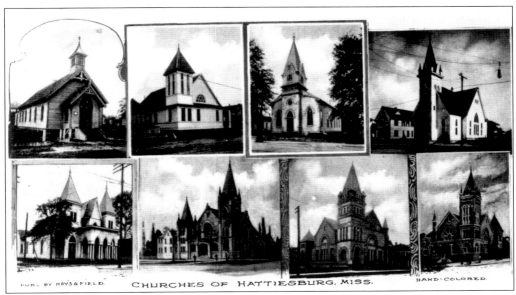

Churches are usually one of the first institutions to appear in any new town, and Hattiesburg is no exception. Three churches existed in the town by the time of incorporation, and by 1918, 41 churches were listed in the city directory. The churches in existence in 1918 represented a variety of denominations, including Baptist, Catholic, Episcopal, Jewish, Methodist, and Presbyterian. At this time, churches were segregated, and 21 of the churches listed were white, while 20 churches served the African-American members of the community. The above images portray eight of the early churches of Hattiesburg. (Image courtesy Mississippi Department of Archives and History.)

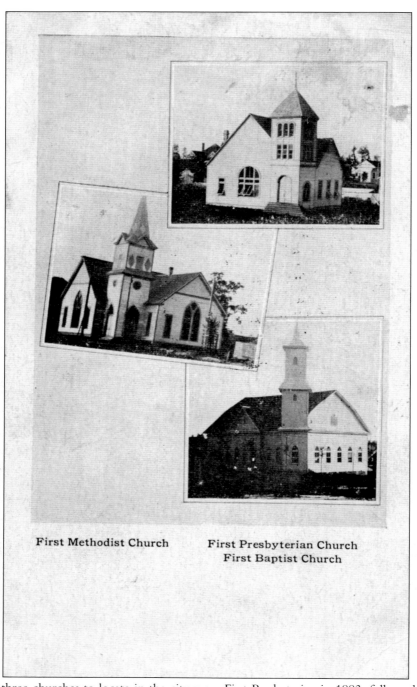

First Methodist Church First Presbyterian Church
 First Baptist Church

The first three churches to locate in the city were First Presbyterian in 1883, followed by First Baptist Church and Main Street Methodist Church in 1884. Labeled above as the First Methodist Church, this building is likely the first church building of Main Street Methodist Church. Printed in the first decade of the 20th century, this postcard is one of the earliest to depict the religious buildings of the city.

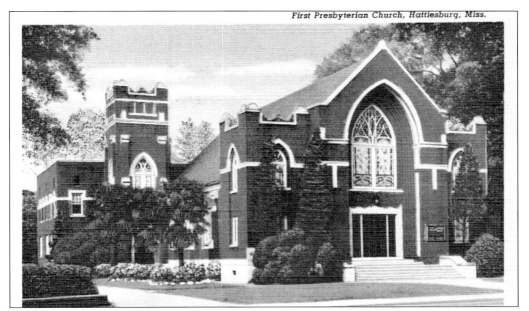

First Presbyterian Church, Hattiesburg, Miss.

First founded at McDonald's Mill in 1882, the First Presbyterian Church moved to Hattiesburg in May of 1883. The sanctuary pictured in this card was the fourth one constructed by the congregation and dates to 1930. The church family moved to a location on West Hardy Street in 1990, and True Light Church occupies this former location on Main Street.

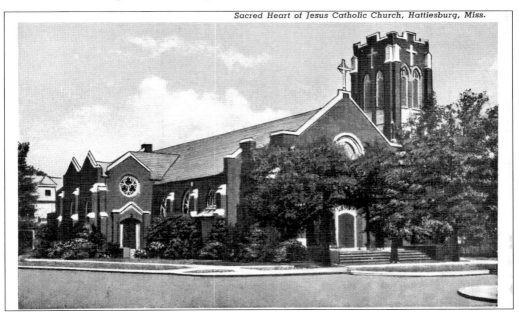

Sacred Heart of Jesus Catholic Church, Hattiesburg, Miss.

The first Catholic church was constructed in Hattiesburg in 1890. Since that time, the Catholic Church has played an active role in Hattiesburg, and outreach of the church has included training nurses for the Hattiesburg Hospital and operation of a school since 1900. The current building housing Sacred Heart Catholic Church, pictured above, was constructed in 1927 at a cost of $65,000.

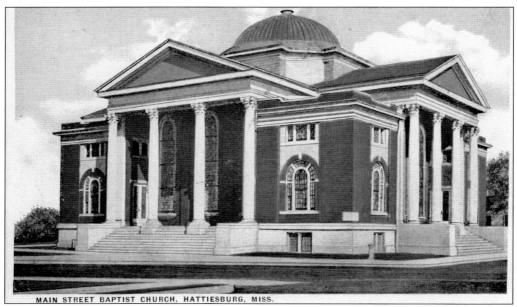

First organized in 1903 as Columbia Street Baptist Church, in 1913 the congregation relocated to a larger site on the corner of Main and Fifth Streets. The same year, the church was renamed Main Street Baptist Church, the title it carries to this day. The postcard above depicts the church building on Main Street, which opened in 1913 and was characterized by the round rotunda crowning the auditorium.

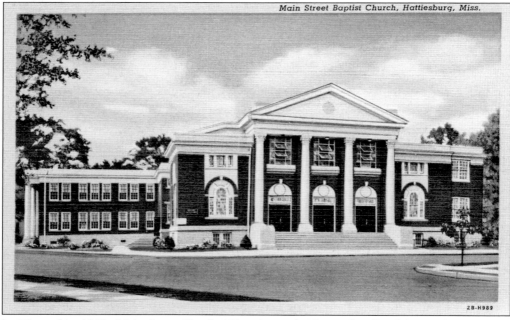

In November 1940, Main Street Baptist Church caught fire and suffered heavy damage. The church was rebuilt and reopened in April 1942 without the glass dome. This postcard shows the building as it appeared in the late 1940s.

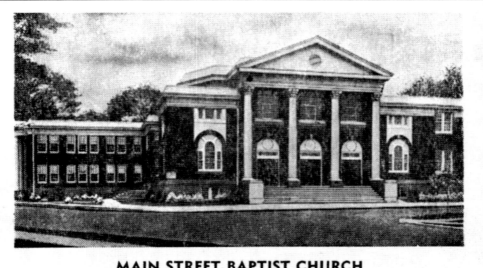

MAIN STREET BAPTIST CHURCH

N. Main at Fifth St. J. E. Barnes, Jr., Pastor Hattiesburg, Miss.

Pastors of the Main Street Baptist Church have included M.J. Derrick, J.N. McMillan, E.D. Soloman, Dr. E.E. Dudley, M.K. Thornton, Sam P. Martin, E.J. Wills, J.D. Barnhill, Dr. John E. Barnes, R. Fred Selby Jr., Dr. Russell Bush, and Jon M. Stubblefield. The above postcard pictures the church as it appeared under the leadership of John E. Barnes, who became pastor of the church in 1944.

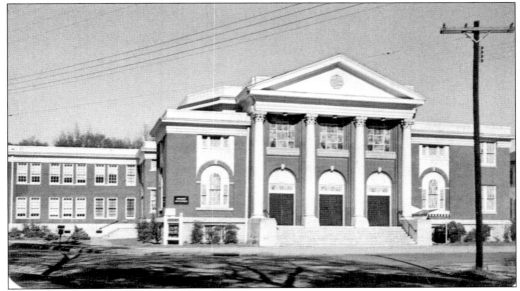

Main Street Baptist Church appears in more postcards than any other Hattiesburg church. The images are often of the building on Main and Fifth Street. The church was rebuilt after a fire and opened in 1942, and its auditorium was again enlarged in 1967. In 1998, Main Street sold its downtown property to Mount Carmel Baptist Church and moved to a new building on Highway 98 West.

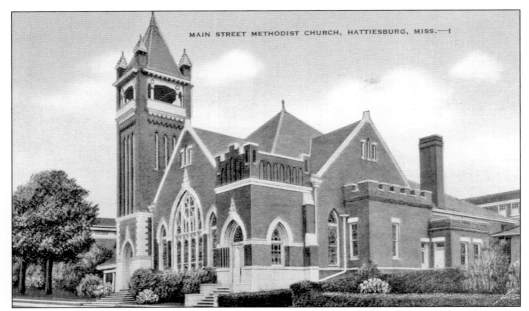

MAIN STREET METHODIST CHURCH, HATTIESBURG, MISS.—I

Main Street Methodist Church is one of the three oldest churches in Hattiesburg and is the oldest church of the Methodist denomination in the city. The first church building was a small frame building, but in 1910, the church moved into a new Gothic revival building located on Main Street. Today, the building is listed on the National Register of Historic Places as part of the Hub City Historic District.

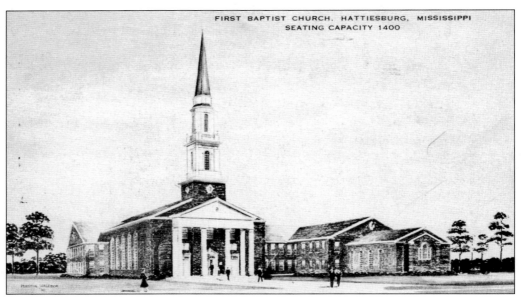

FIRST BAPTIST CHURCH, HATTIESBURG, MISSISSIPPI
SEATING CAPACITY 1400

Founded in 1884, the First Baptist Church of Hattiesburg is the oldest church of that denomination in the city. Two church buildings preceded the building pictured here, which was opened in 1953 with construction costs of $675,000. First Baptist Church is the progenitor of several other area churches, including Main Street Baptist, Immanuel Baptist, and Temple Baptist Churches.

Three
HOTELS, MOTELS, AND ROADSIDE STOPS

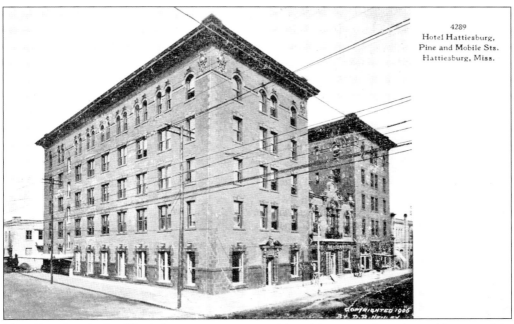

4289
Hotel Hattiesburg,
Pine and Mobile Sts.
Hattiesburg, Miss.

The first hotels in Hattiesburg arose to provide visitors to the city with overnight accommodations. By 1905, eight establishments offered lodging services to guests: the Commercial Hotel, the Criterion Hotel, the Dobbins House, the Hotel Klondike, the Royal Hotel, the Wiedmann Café, the Windsor Café, and the Model Café. The next year, the Hotel Hattiesburg would open in the city and for the next two decades would represent the standard that all other lodging establishments in the city strived to match. All of these hotels were located downtown and mainly served visitors who arrived in the city by rail. The photograph above depicts the Hattiesburg Hotel in its inaugural year.

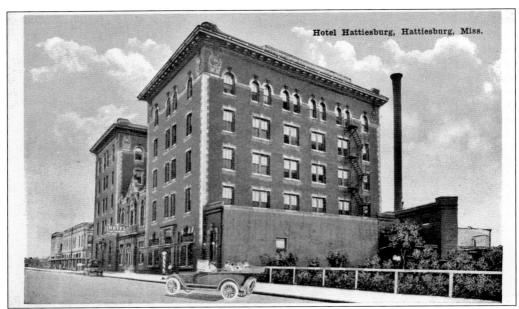

Located at the corner of Pine and Mobile Streets, the Hotel Hattiesburg was constructed and owned by Joseph Thomas Jones, the owner of the Gulf and Ship Island Railroad. Jones already owned the Great Southern Hotel in Gulfport and wanted an elegant facility in Hattiesburg to serve railroad passengers. Constructed at a cost of $298,000, the building opened in 1906 and also served as the terminal for the Gulf and Ship Island Railroad.

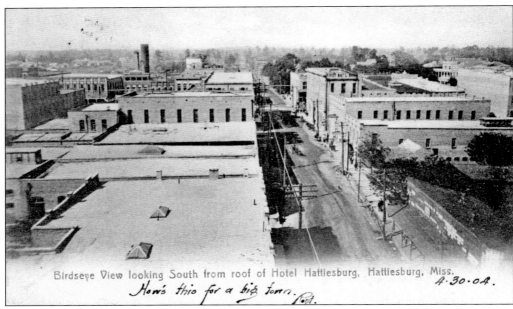

This view from the top floor of the five-story Hotel Hattiesburg offers an excellent vista of downtown. At the time this image was taken, the Hotel Hattiesburg was the second tallest building in the city, rivaled only by the Carter Building and the Ross Building. Built in the classical revival style, the building fell into disrepair by the 1950s and was leveled in 1961.

In 1929, the Forrest Hotel opened on West Pine Street in downtown Hattiesburg. It was constructed at a cost of $500,000 and is the tallest building in downtown. The art deco building replaced the Hotel Hattiesburg as the premiere lodging facility in the city. During the 1930s, the hotel employed 75 people and was operated by the Maybar Hotel Corporation, under ownership of the Forrest Hotel Corporation. The arrival of the automobile and advent of the motor hotel would move lodging options to the fringe of the city and ultimately lead to the closure of the hotel.

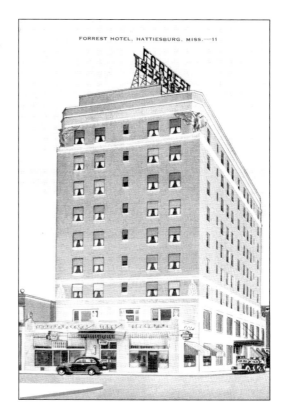

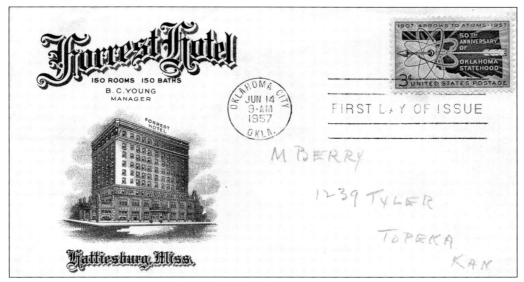

This envelope from the 1950s lends a slightly different view of the hotel's exterior. The facility boasted 150 guest rooms, a coffee shop, and banquet facilities. A 1942 advertisement lists each room as air-conditioned and furnished with cold water.

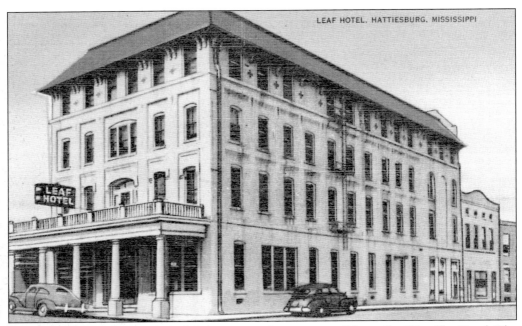

The Leaf Hotel, with its trademark balcony, was the successor of the earlier Klondike Hotel. The facility was also once known as the Hotel Mitchell. This four-story building was located on the 400 block of Main Street.

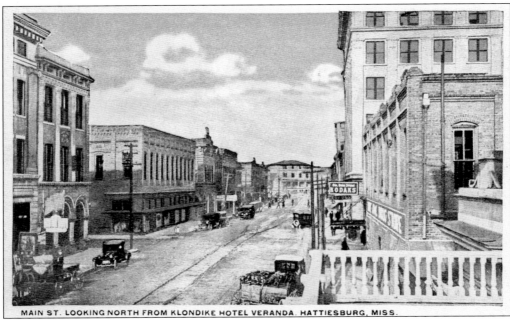

This scene of a busy downtown Hattiesburg dates to the second decade of the 20th century. Wagons, streetcars, and automobiles all share an unpaved Main Street. The Owl Drug Store is located just to the right of the hotel. This photograph was taken from the open balcony pictured on the Leaf Hotel image above.

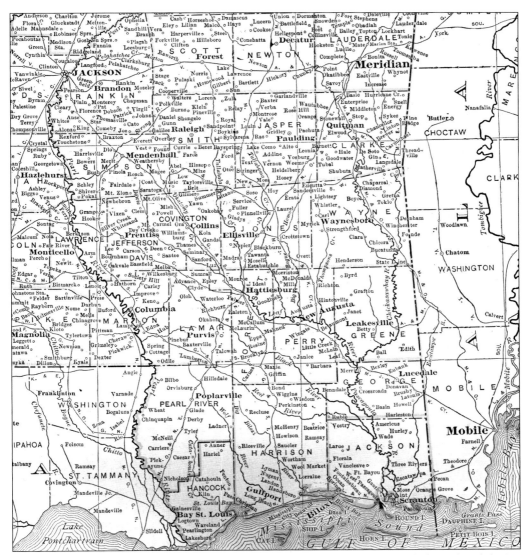

The visitors who utilized Hattiesburg's lodging establishment arrived primarily by railroad during the first two decades of the 20th century. Therefore, most of the hotels were located in the downtown area. This 1911 railroad map shows the Hub City with its radiating railroad lines.

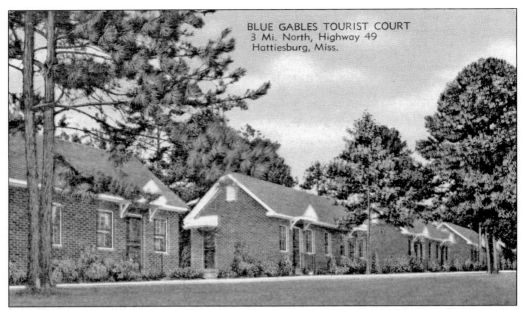

BLUE GABLES TOURIST COURT
3 Mi. North, Highway 49
Hattiesburg, Miss.

After 1930, the automobile increasingly became the preferred method of transportation for Americans. As highway routes developed, travelers began to stop at smaller lodging facilities along the roadway. Tourist courts, such as the Blue Gables pictured above, placed travelers in smaller versions of their homes, sending them on to the next destination after a comfortable night's rest.

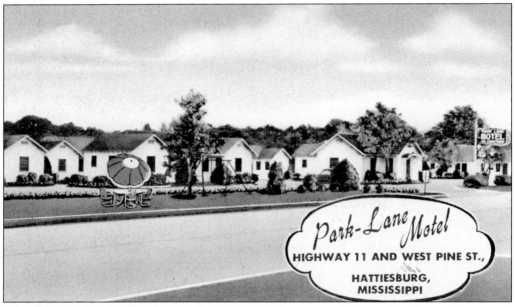

Park-Lane Motel
HIGHWAY 11 AND WEST PINE ST.,
HATTIESBURG,
MISSISSIPPI

The Park Lane Motel offered much the same type of accommodation as the Blue Gables Tourist Court: small, individual cottage-type lodging for the visitor. The Park Lane was located along the main thoroughfare for travelers from New Orleans to Meridian on Highway 11. Until the construction of the Eisenhower Interstate System in the late 1950s, this route was heavily traveled by those passing through the city toward Birmingham, Chattanooga, and Atlanta.

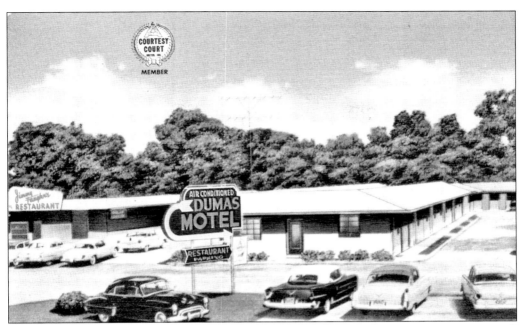

The word motel refers to a "hotel where rooms are accessible from an outdoor parking area." The Dumas Motel, located on Highway 11 in Hattiesburg, contained rooms under one roof and was designed to be convenient to automobile travel. The Dumas Hotel is still in business today.

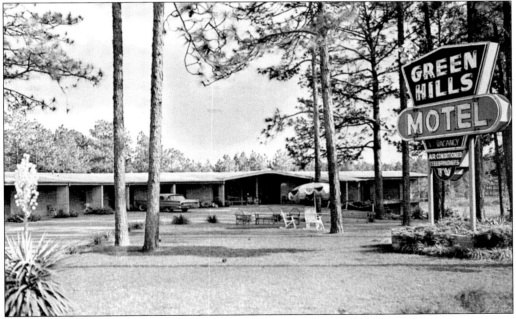

The Green Hills Motel offered the comfort and convenience of air-conditioning and television, two new technologies that lodging establishments were required to have by the mid–20th century to be competitive. Like many of the other early motor hotels in Hattiesburg, it was located on U.S. Highway 11.

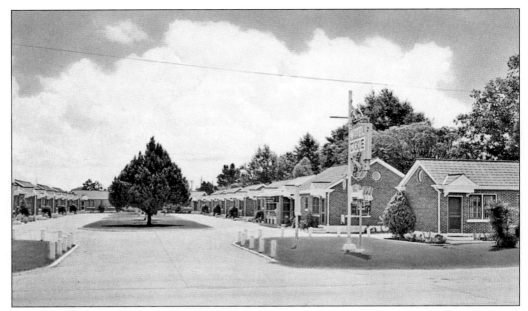

Themes of Confederate heritage were popular in the Deep South during the middle part of the 20th century, and the Motel Dixie used symbols of the Old South, including the rebel flag, to attract customers. This motor court hotel featured a freestanding building divided into duplex rooms and was located at 601 Highway 11 South.

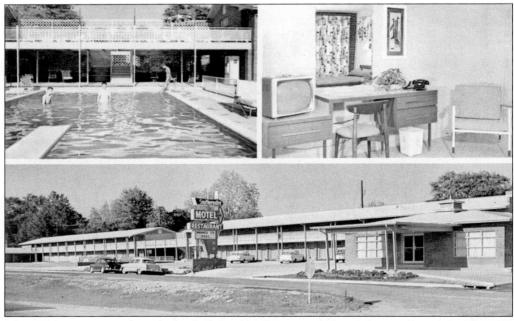

The Southernaire Motel was located adjacent to the intersection of U.S. Highway 49 and Hardy Street in Hattiesburg. Originally, the route of Highway 49 went through downtown Hattiesburg, but in the early 1950s, the current roadway, then referred to as the Highway 49 Bypass, was constructed. Although the structure still stands, it is no longer utilized as a motel.

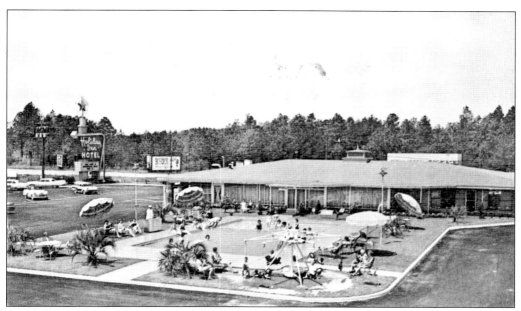

Another business venture that first developed in Memphis, Kemmons Wilson opened his first Holiday Inn Hotel in Hattiesburg on Summer Avenue in 1952. Offering quality rooms and affordable rates, the chain soon expanded across the nation. The first Holiday Inn in Hattiesburg was located at the intersections of Highway 49 and Highway 11, an area locally known as the "cloverleaf" for its shape.

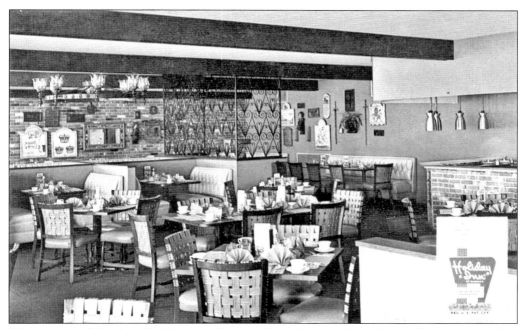

The interior of the first Holiday Inn Hotel in Hattiesburg is shown here. The exterior of the same hotel is shown above. In 1962, nightly rates for rooms at the Holiday Inn were between $6 and $11.

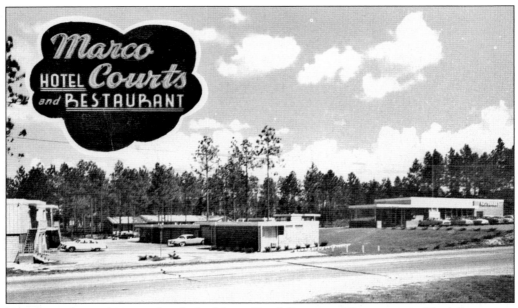

Here is another early motor hotel, the Marco Hotel Courts and Restaurant in Hattiesburg.

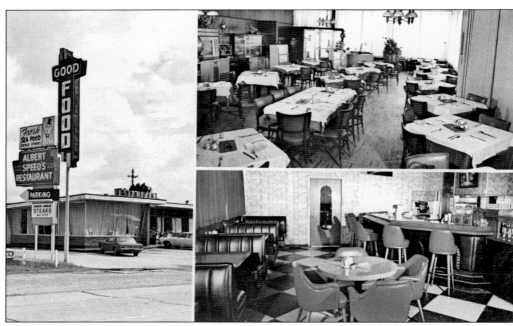

Located at 304 Broadway Drive, Albert Speed's Restaurant was a Hattiesburg landmark. After serving in England during World War II, Speed returned to Hattiesburg, and after working at Gray's Ice Cream, he was eventually able to open his own eatery. The slogan for the restaurant was "Where Friends Meet For Good Things To Eat."

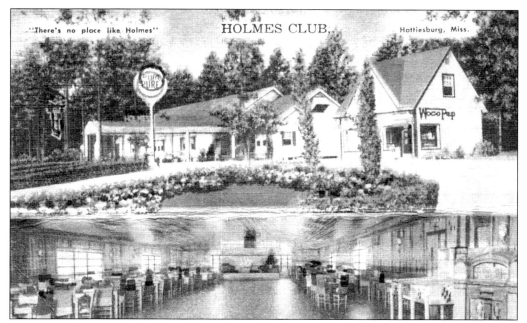

With the advent of the automobile, travelers not only needed lodging, but they also needed to refuel and service their vehicles as well. This local station served as both an eatery and a gas station. Waco Pep was the trade name for the Pure Oil Company, the distributor of fuel to the Holmes Club.

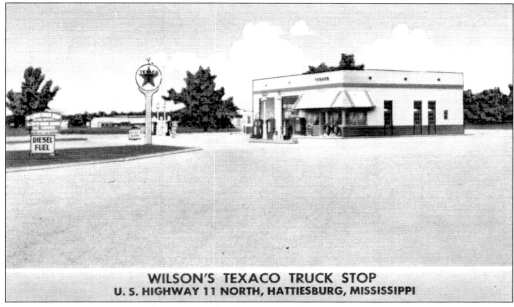

The Texas Company was founded at the beginning of the 20th century in Beaumont, Texas. By 1911, the company opened its first service station, and by the 1930s, it was fueling cars with Texaco brand fuel. This postcard of Wilson's Texaco in Hattiesburg features the trademark red star.

"THE SOUTH'S BEST AIR-CONDITIONED REGION"

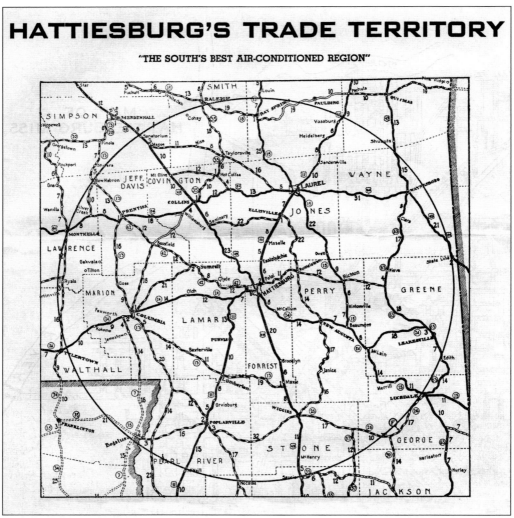

The above map shows the development of highway routes in Mississippi, *c.* 1939. Much as Hattiesburg became a railroad center during the first decade of the 20th century, in the late 1930s, Hattiesburg became a focus for highway development in the region. In particular, the city's location at the center of U.S. Highways 11 and 49 insured transportation links with Jackson, Meridian, New Orleans, and the Gulf Coast. By 1939, Hattiesburg was the largest retail center in South Mississippi, outpacing her regional rival to the north, Laurel. Hattiesburg was the dominant force in an eight-county trade area encompassing Covington, Forrest, Greene, George, Jefferson Davis, Lamar, Pearl River, and Stone. The population of the town was 20,026 in 1940 and would climb to 34,989 in 1960.

Four

CENTER OF
HIGHER EDUCATION

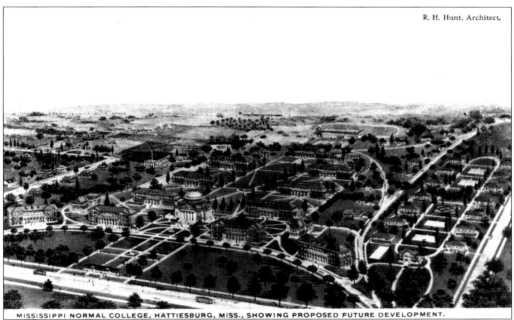

MISSISSIPPI NORMAL COLLEGE, HATTIESBURG, MISS., SHOWING PROPOSED FUTURE DEVELOPMENT.

In 1910, the Mississippi legislature enacted House Bill Number 204, creating a new institution of higher learning, Mississippi Normal College. Later that year, Hattiesburg was selected as the site for the college, which would open in 1912. The new campus was situated between Hardy Street and the Mississippi Central Railroad on cutover pineland and would need suitable buildings to accommodate the first class of students. Rueben Harris Hunt of Chattanooga, Tennessee, was selected to design the first buildings on campus. The layout above was his vision of how the campus would take shape. Although not followed in its entirety, Hunt did design the initial five buildings on campus, which are know today as College Hall, Forrest County Hall, Hattiesburg Hall, the Honor House, and the Ogletree Alumni House. (Image courtesy Mississippi Department of Archives and History.)

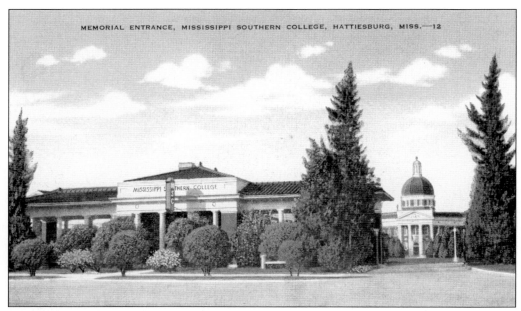

Mississippi Normal College opened for classes in September 1912. After the First World War, a fund was established to build a memorial to honor the soldiers of the war. The cornerstone for the memorial was laid in 1921. The World War I Memorial Entrance was located at the entrance to campus on Hardy Street.

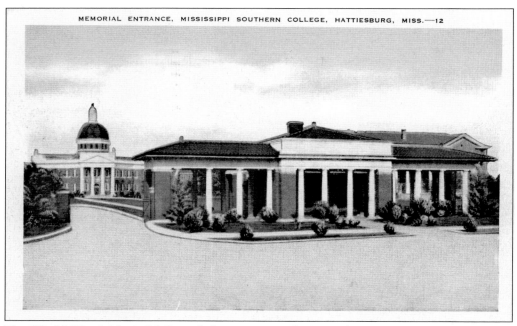

The World War I Memorial fronted the campus until 1966, when an encounter with a truck damaged the integrity of the building. Unfortunately, the structure was dismantled and not rebuilt. The memorial contained a small apartment, and the Reverend W.E. Fail and his wife lived there for many years.

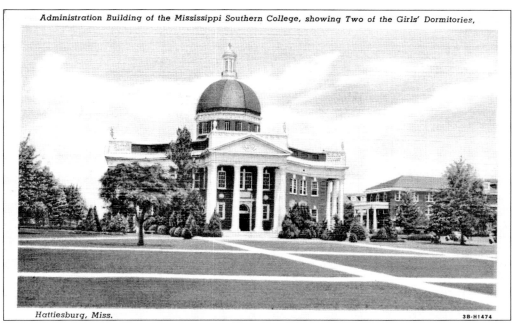

Growth came rapidly for Mississippi Normal College. In 1922, the first baccalaureate degree was awarded by the college, and in 1924, the name of the institution was changed to State Teachers College. The expansion in scope and students required a new building to house the administration of the young college. Designed by architect Vinson B. Smith Jr. in the neoclassical revival style, the Administration Building opened in 1928.

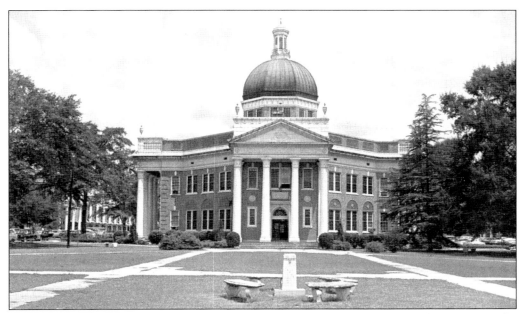

The Administration Building faces Hardy Street, at the main entrance to the campus. The building was renamed the Aubrey K. Lucas Administration Building, in honor of the sixth president of the university, who served from 1975 to 1996.

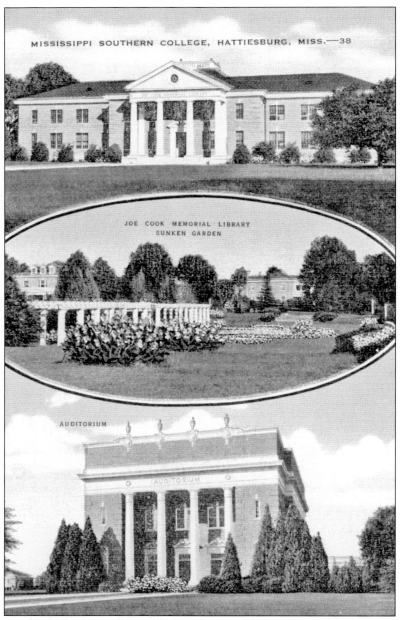

MISSISSIPPI SOUTHERN COLLEGE, HATTIESBURG, MISS.—38

JOE COOK MEMORIAL LIBRARY
SUNKEN GARDEN

AUDITORIUM

AUDITORIUM

In 1940, the name of State Teachers College was changed to Mississippi Southern College. That same year, the Joseph Cook Memorial Library opened east of the Administration Building. Named after the first president of the institution, the first Cook Library building was the edifice today known as Kennard-Washington Hall. After the Cook Library moved to its present location in 1960, the building was used for a variety of administrative functions. The building was renamed Kennard-Washington Hall in 1993 in memory of Clyde Kennard and Dr. Walter Washington. Kennard unsuccessfully attempted to enroll at the then Mississippi Southern College in 1959. Walter Washington was the first African American to receive a doctoral degree from the university in 1969. The postcard above pictures the building as it appeared in the early 1940s.

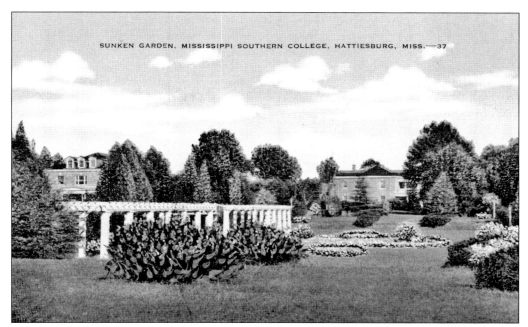

The Sunken Gardens represent a little known and now lost piece of Southern Miss history. Constructed as a class project from 1929 to 1932, the landscaped gardens were located where McLemore Hall now stands. The gardens were displaced during the construction of McLemore Hall, which opened in 1956.

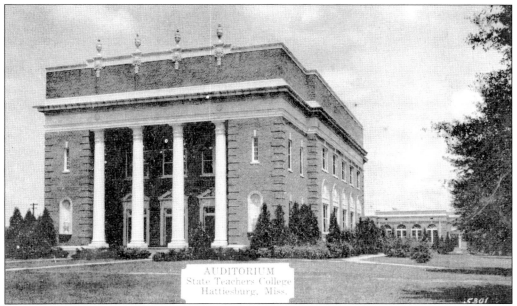

AUDITORIUM
State Teachers College
Hattiesburg, Miss.

Designed in the same year as the Administration Building, the Bennett Auditorium shares the same architect as well. Designed by Vinson B. Smith Jr. in the neoclassical style, the auditorium opened in 1930. In 1972, the building was named in honor of the school's second president, Claude Bennett, who led the school from 1928 to 1933.

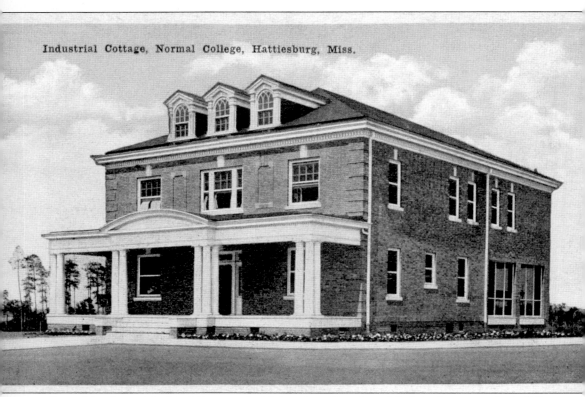

Industrial Cottage, Normal College, Hattiesburg, Miss.

One of the five original buildings on the University of Southern Mississippi campus, the building first named the Industrial Cottage was designed by R.H. Hunt. Constructed in 1912 by I.C. Garber, the building's purpose was to allow young women to practice domestic service. The building has served in several other capacities since that time, including a stint as the college's infirmary and as a faculty residence. The building gained the name Honor House in 1957 when upper-class and graduate women were allowed to live in the house "on their honor." Today, the building houses the University of Southern Mississippi Foundation.

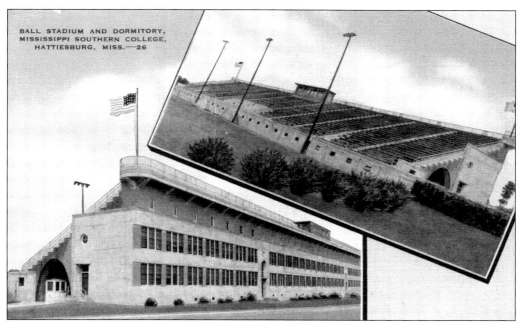

The history of Southern Miss's football stadium, known today by its nickname "The Rock," dates to 1932 when Faulkner Field was completed. The east side of the stadium, pictured in the above postcard, c. 1940, opened in 1939 and was constructed in part by members of the football team. In addition to serving as the football stadium, it also served as a men's dormitory.

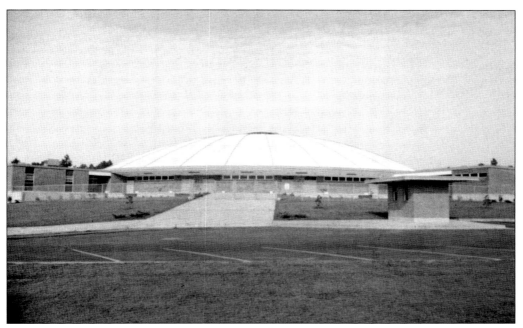

Reed Green Coliseum was completed in 1965. The facility serves as home of the Southern Miss men's and women's basketball programs.

In 1959, construction began on a new Joseph Cook Library to replace the old facility, then located in Kennard-Washington Hall. The building was expanded in 1968 and underwent a major renovation and expansion in 1996. The original entrance to the library faced Hardy Street. Today, this is the employee entrance.

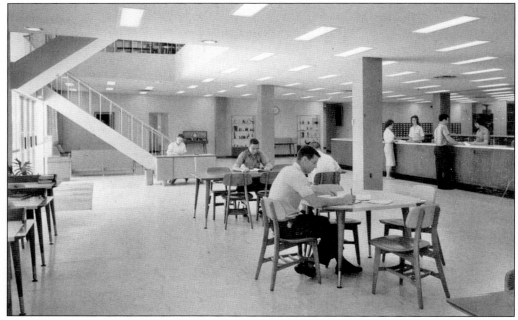

After entering the library, patrons entered the lobby and reference area. The library's card catalog can be seen in the background.

University President William McCain actively sought to expand Mississippi Southern College. One method of expansion was physical, and the Walker Science Building, erected during the late 1950s, was just one of the building projects that he initiated soon after arriving in Hattiesburg in 1955. McCain's crowning achievement, however, was guiding the college to university status in 1962, when it became the University of Southern Mississippi.

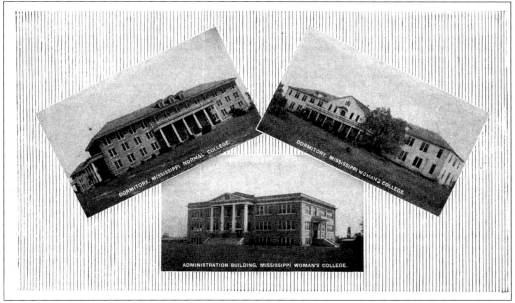

By 1920, when this image appeared in a Southern Railway postcard folder, the city of Hattiesburg boasted two institutions of higher learning: Mississippi Normal College, today the University of Southern Mississippi, and Mississippi Women's College, now William Carey College. Each would grow and prosper during the course of the 20th century. The two facilities have made Hattiesburg the center for higher education in the region.

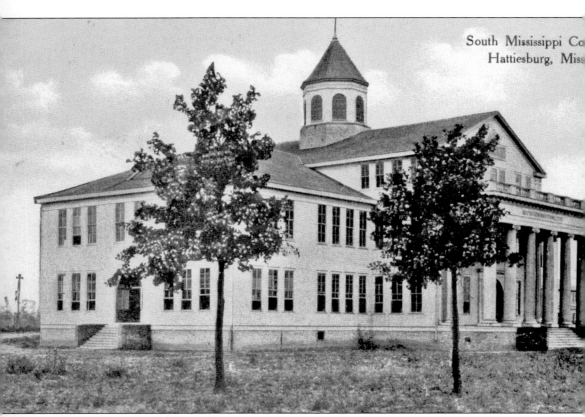

South Mississippi Co
Hattiesburg, Miss

The first college to call Hattiesburg home was South Mississippi College, which was established south of the city in 1906. The college operated under the direction of President W.I. Thames and Vice President H.P. Todd, and during 1908, it had a staff of 16 and nearly 400 students. The tenure of the school was brief, however, as in 1909, a fire destroyed the administration building, pictured above in this rare vintage postcard. The building was the center of the small college and included a 1,500-seat auditorium, classrooms, a library, and offices. After the fire, President Thames moved to Picayune to become superintendent of the city's high school. The future of the site would remain in question until 1911.

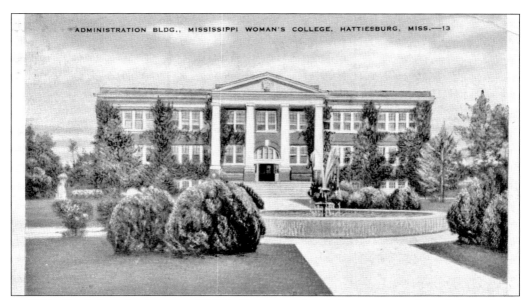

In 1911, Hattiesburg businessman W.S.F. Tatum purchased the property of the defunct South Mississippi College, which consisted of the remaining two frame buildings and 10 acres of land. Tatum offered the facility to the Baptist Church, and in the inaugural year 1911, the facility operated as Mississippi Women's College under the directorship of a local board of trustees and President W.W. Rivers. Control of the school was transferred to the Mississippi State Baptist Convention in November 1911. The school remains under the governance of the Mississippi Baptist Convention today.

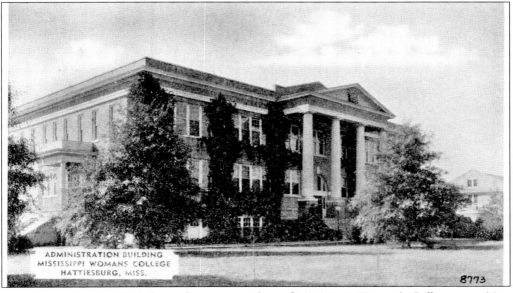

ADMINISTRATION BUILDING
MISSISSIPPI WOMANS COLLEGE
HATTIESBURG, MISS.

8773

On July 1, 1912, Dr. J.L. Johnson became president of Mississippi Women's College, a position he would hold until his death in 1932. During his 20-year tenure, the college grew quickly. An example of this growth was the construction of a new administration building, today known as Tatum Court. The building is named after benefactor W.S.F. Tatum.

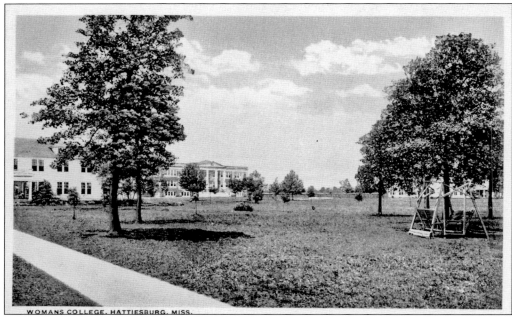

WOMANS COLLEGE, HATTIESBURG, MISS.

When purchased by Tatum in 1911, the campus was composed of cutover pineland. This early view portrays the campus as it appeared in the 1930s. Tatum Court, the administration building, can be seen in the background in the center of the image.

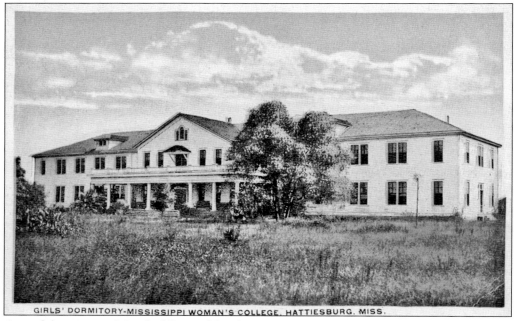

GIRLS' DORMITORY-MISSISSIPPI WOMAN'S COLLEGE, HATTIESBURG, MISS.

One of the two surviving buildings of South Mississippi College was the girl's dormitory. The building became part of Mississippi Women's College when it was transferred to the control of the Mississippi Baptist Convention.

Five

CAMP SHELBY

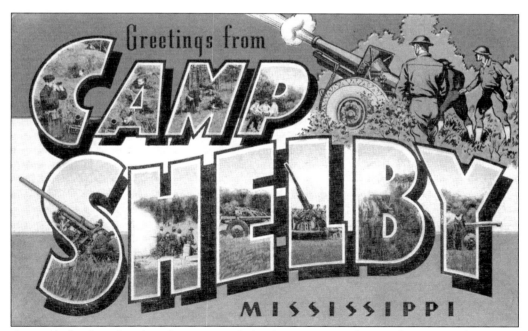

Camp Shelby has played an important role in the economy of Hattiesburg since the camp's founding in 1917. Although founded as a federal facility, Camp Shelby is today the largest state-owned and -operated training facility in the nation. The large number of visitors has also resulted in a wide variety of postcards being published that either depict the base or carry the name of the facility. The card pictured here is from the World War II era.

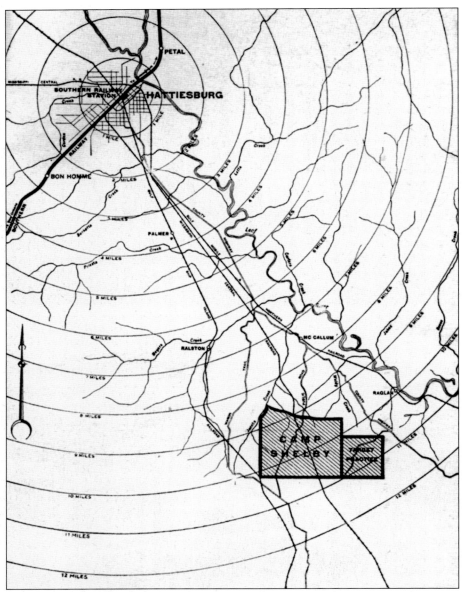

Camp Shelby is located roughly 10 miles southeast of Hattiesburg. Named by members of the 38th Division, Camp Shelby's namesake is Isaac Shelby of Kentucky. Shelby gained fame in the American Revolution and was the first governor of the Commonwealth of Kentucky in 1792. At age 63, Shelby organized a group of Kentucky soldiers to march against the British in the War of 1812. Fighting under future President William Henry Harrison, his troops helped defeat the British and their Native American allies at the Battle of the Thames, where noted leader Tecumseh was killed. Shelby would later serve a second term as governor of Kentucky from 1812 to 1816. The above map, c. World War I, gives a detailed view of the relationship of the city and the military camp. At this time, ingress and egress was mainly by rail line, and the Mississippi Central tracks ran directly through the base. Today, U.S. Highway 49 is the main transportation route utilized to reach the facility.

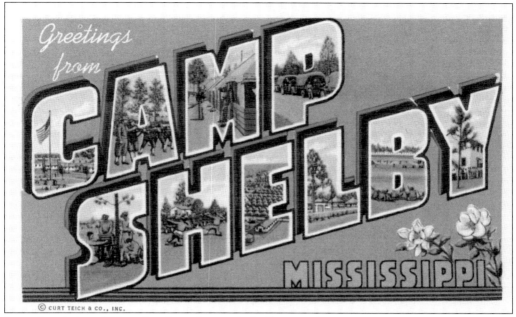

Several varieties of "Greeting from Camp Shelby" postcards were produced during World War II, mainly by the Curt Teich Company. Curt Teich produced over 150 images of Hattiesburg and Camp Shelby between 1898 and 1978. This image is from a postcard packet, which were common during World War II. Each packet contained 16 to 18 scenes of a particular locale.

Camp Shelby, Camp Shelby, Miss.

PHOTOS BY U. S. ARMY SIGNAL CORPS *U. S. Field Artillery* © CURT TEICH & CO., INC.

Here is another multi-view card from the World War II era. Once again, Curt Teich is the publisher.

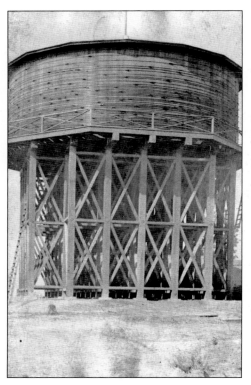

The structure pictured here is likely a water tower. Camp Shelby grew rapidly after its selection as a federal training site in July of 1917. Facilities to service 40,000 men had to be readied quickly, as troops were dispatched to Shelby for training in the fall of 1917.

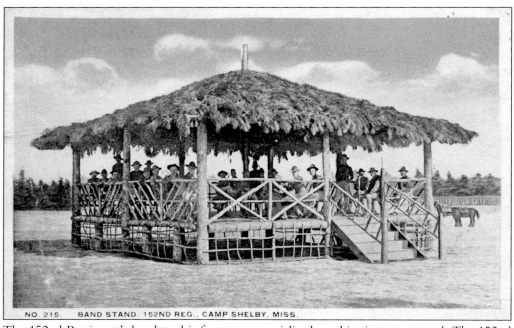

NO. 215. BAND STAND. 152ND REG., CAMP SHELBY, MISS.

The 152nd Regiment's bandstand is forever memorialized on this vintage postcard. The 152nd was a unit of the 38th Infantry Division, one of the first divisions to train at Shelby during the First World War.

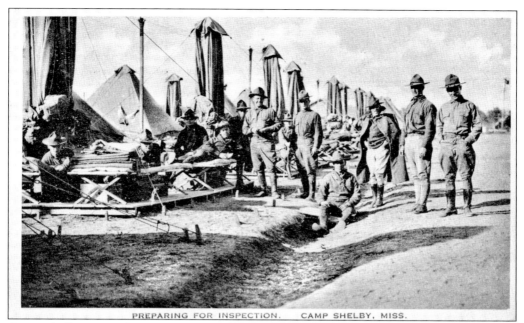

PREPARING FOR INSPECTION. CAMP SHELBY, MISS.

Camp Shelby was only a temporary stop for most soldiers. During their time in Mississippi, the soldiers trained for the fighting they would likely encounter in Europe. This group of soldiers is definitely posing for the camera, even though the caption of the card reads "preparing for inspection."

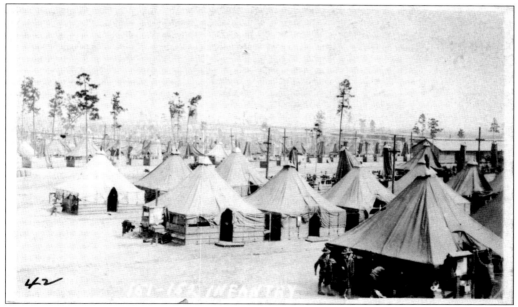

Life for soldiers at Camp Shelby during World War I meant life in tents. Although more than 1,000 buildings were constructed on the post before its deactivation in 1918, there were not nearly enough to accommodate the large influx of soldiers. The tents' bottoms and lowers were of wood construction.

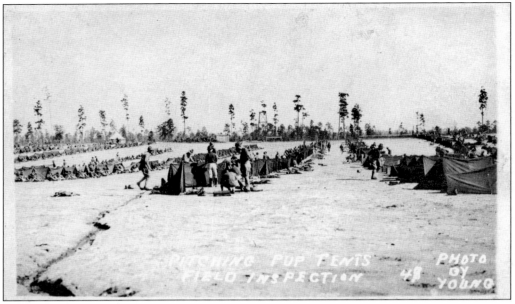

The barren landscape of Camp Shelby during World War I is evident in this striking image. Much of the area was cut over timberland and offered wide-open spaces for military maneuvers. These soldiers are in the process of pitching their field tents.

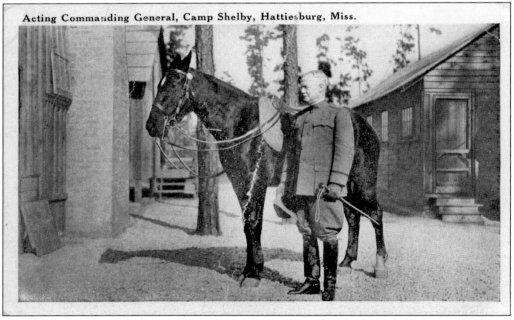

Although motorized vehicles were used during the First World War, the horse was still very much in demand as a source of transportation. Here, Shelby's camp commander poses next to his mount in riding attire.

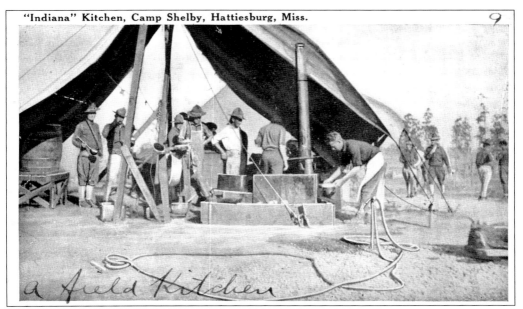

a Field Kitchen

Here, members of an "Indiana" regiment are at work preparing a meal for hungry fellow soldiers in the field kitchen. Many of the troops who trained at Camp Shelby during World War I were from Indiana, Kentucky, or West Virginia. These troops are likely part of the 38th Division. The division was also known as the "Cyclone" division, a nickname gained when a severe storm leveled the tents of the unit during April of 1918. The logo of a large "C" with a small "y" began to appear on the patches of the troops later that year. Luckily, the weather on this day appears to be cooperative.

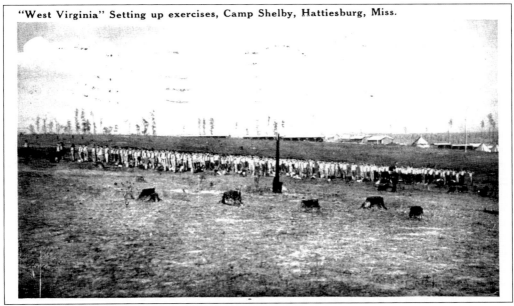

"West Virginia" Setting up exercises, Camp Shelby, Hattiesburg, Miss.

These West Virginia troops are also part of the 38th Division. The soldier who penned this card, mailed in the fall of 1918, states, "So far camp life is just to my liking."

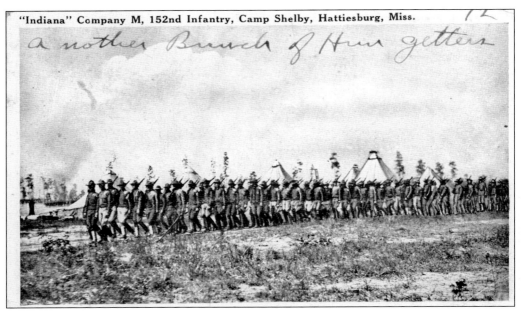

"Indiana" Company M, 152nd Infantry, Camp Shelby, Hattiesburg, Miss.

a nother Bunch of Hun getters

The 152nd Infantry Regiment was part of the 76th Infantry Brigade of the 38th Division. These troops were composed mainly of men from the Indiana National Guard. Reflective of the anti–German sentiment of the war, the sender has noted that this group is "another bunch of hun getters."

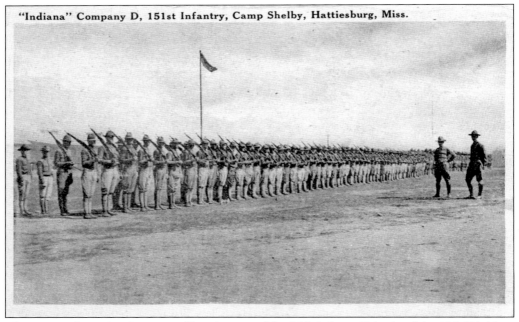

"Indiana" Company D, 151st Infantry, Camp Shelby, Hattiesburg, Miss.

The 151st Infantry Regiment was likewise part of the 76th Infantry Brigade of the 38th Division. Formed from the Indiana National Guard, this regiment was transferred overseas to fight in France in 1918.

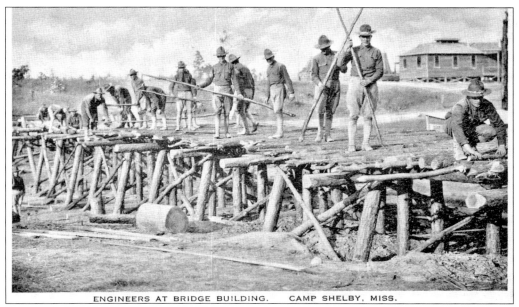

ENGINEERS AT BRIDGE BUILDING. CAMP SHELBY, MISS.

The 113th Engineer Regiment served as both engineers and topographers for the 38th Division. One of the problems the unit encountered was the lack of adequate maps of Camp Shelby, but by the time of their departure in fall of 1918, the topographical unit had mapped more than 200 square miles of territory in and around Camp Shelby. The symbol of the 113th Engineers was a castle.

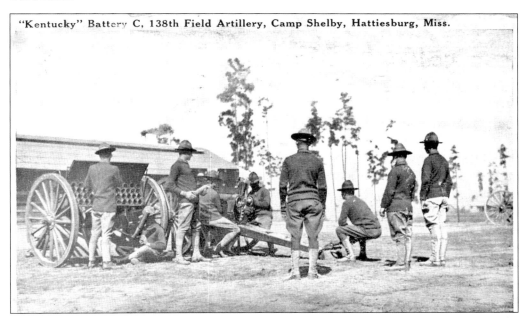

"Kentucky" Battery C, 138th Field Artillery, Camp Shelby, Hattiesburg, Miss.

The 138th Field Artillery was part of the 63rd Field Artillery Brigade of the 38th Division. The unit was organized out of Kentucky National Guard troops assigned to Camp Shelby. Other units that made up the 63rd Field Artillery Brigade during World War I were the 137th Field Artillery Regiment, the 139th Field Artillery Regiment, and the 113th Trench Mortar Battery.

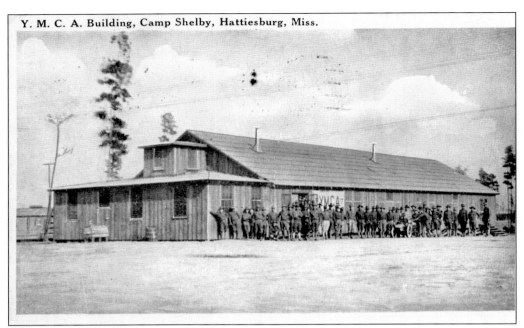

Y. M. C. A. Building, Camp Shelby, Hattiesburg, Miss.

Although Hattiesburg's YMCA building was nearing completion, a separate facility was built on base for the use of World War I soldiers. The typical YMCA of World War I also served as a base canteen.

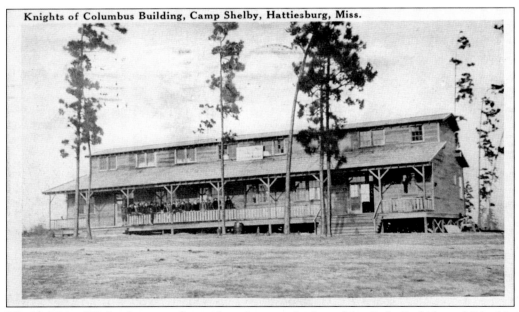

Knights of Columbus Building, Camp Shelby, Hattiesburg, Miss.

The Knights of Columbus are a fraternal service organization of the Catholic faith established in 1881. During World War I, the Knights of Columbus established clubhouses in military bases across the nation. The clubhouses not only provided a chaplain and a place for Catholic service members to engage in worship, but they also provided recreational activities to men of any race or religious background.

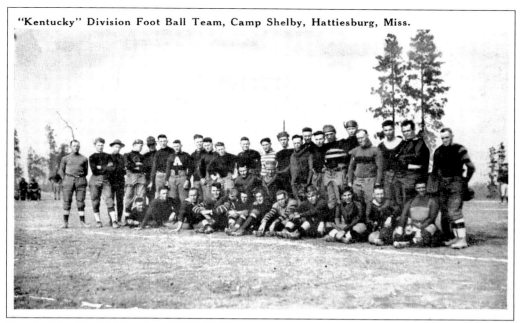

"Kentucky" Division Foot Ball Team, Camp Shelby, Hattiesburg, Miss.

Training for World War I at Camp Shelby was strenuous, but service men still found time to engage in popular sporting events such as football. Pictured here are the members of the Kentucky Division team, part of the 38th Division, *c.* 1918.

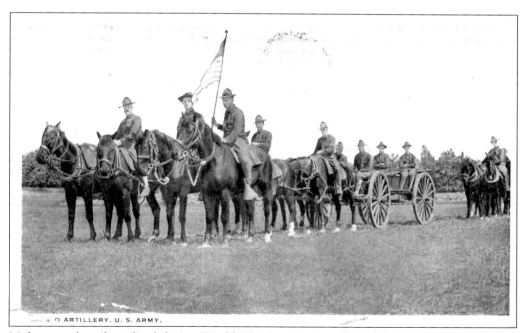

Mules were heavily utilized during World War I to move artillery. The gun in tow is likely a 75mm, the standard piece operated by two of the brigade's regiments. This postcard depicts members of the 63rd Field Artillery Brigade on the move.

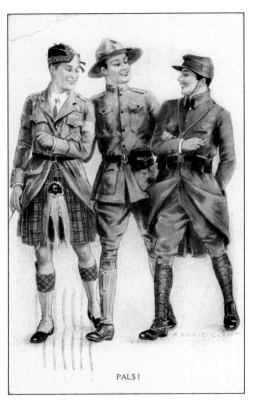

PALS!

Archie Gunn was born in 1863 and died in 1930. A popular painter and artist, he produced a series of postcards during World War I depicting joyful and patriotic scenes. Mailed from Camp Shelby, this card is entitled "Pals!"

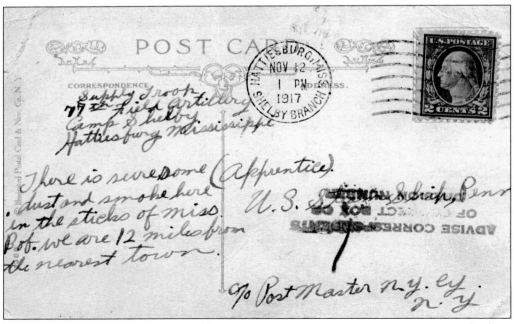

The sender of this card complained of the lack of nearby urbanity, stating, "we are 12 miles from the nearest town."

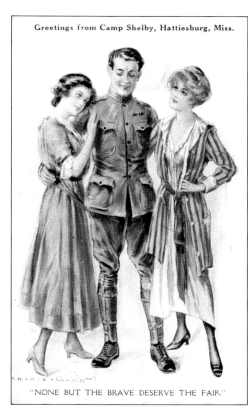

"NONE BUT THE BRAVE DESERVE THE FAIR"

Unlike the image on the previous page, the two Archie Gunn postcards pictured here both bear the recipient "Greetings from Camp Shelby." Each of the cards in this series was sold across the nation but were imprinted with the name of the local camp or base. The patriotic theme is evident in both cards, as diligent soldiers are shown receiving the affection of grateful young women.

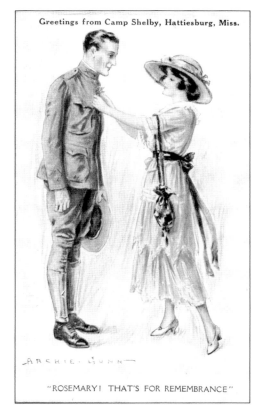

"ROSEMARY! THAT'S FOR REMEMBRANCE"

SKELETON MAP OF DOWNTOWN HATTIESBURG

Showing Points of Interest and Principal Streets

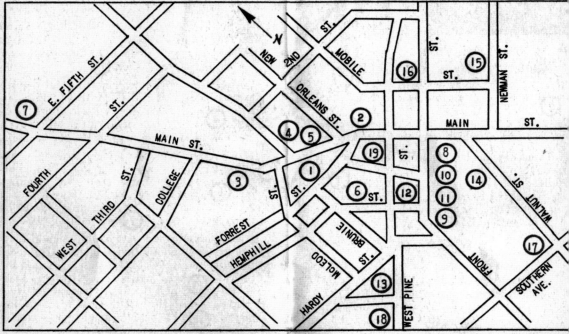

1. Main St. Methodist Church (Main)
2. Court House (Main)
3. First Presbyterian Church (Main)
4. Public Library (Main)
5. Y.M.C.A. (Main)
6. Y.W.C.A. (Hemphill)
7. Main St. Baptist Church (Main)
8. Soldier Service Center (Front)
9. U.S.O.—Official (Front)
10. Teche Greyhound Bus Station (Front)
11. Lutheran Service Center (Front)
12. City Hall (Forrest)
13. U.S.O.—Synagogue and Jewish (W. Pine)
14. Tri-State Bus Station (Walnut)
15. Southern Depot (Newman)
16. Illinois Central Depot (Mobile)
17. Catholic Church (Walnut)
18. Episcopal Church (W. Pine)
19. Post Office (W. Pine)

Camp Shelby was deactivated after the close of World War I, and all but four of the permanent buildings were removed. In 1934, the State of Mississippi acquired the property from the federal government to use as a training facility. In late 1940, Camp Shelby was reopened as a federal facility, and the camp became a beehive of construction activity. With the outbreak of war in December 1941, Camp Shelby once again became an army training facility and would remain so until the end of the war. Soldiers by the thousands trained at Shelby, but when time for leave came, they often boarded a train for Hattiesburg. This map of Hattiesburg was designed to familiarize the soldier with main points of interest in downtown.

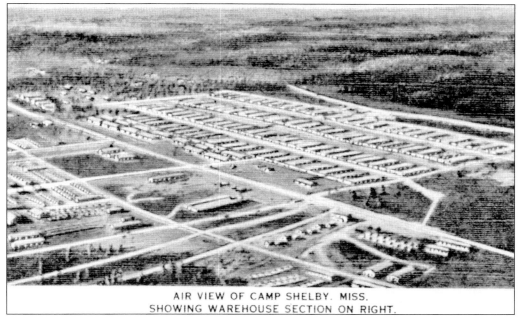

AIR VIEW OF CAMP SHELBY. MISS.
SHOWING WAREHOUSE SECTION ON RIGHT.

Rapid development characterized the rebirth of Camp Shelby as a federal training facility. Beginning in the fall of 1940, the base became the site of a fervent construction project, employing thousands of workers from Hattiesburg and the surrounding piney woods. According to local newspapers accounts, by October of 1940, more that 12,000 workers were erecting the infrastructure necessary to support 50,000 soldiers in training. A majority of the construction was complete by 1943.

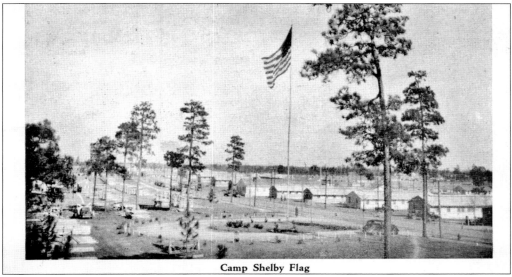

Camp Shelby Flag

The United States flag is a longstanding symbol of American pride, and postcard packs of Camp Shelby from World War II often included an image similar to the one above. The post flag was 10 by 19 feet, but sometimes a mammoth garrison flag that measured 20 by 38 feet rose high above the camp.

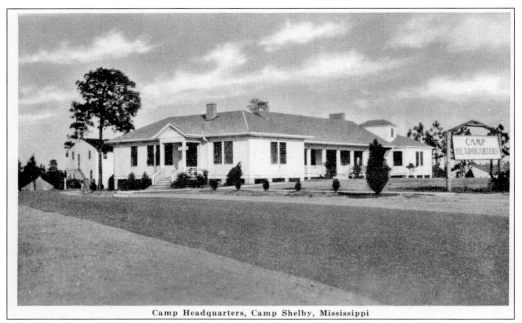

Camp Headquarters, Camp Shelby, Mississippi

The administrative center of the base was camp headquarters, as pictured in this *c.* 1943 postcard. Constructed by the Works Progress Administration in 1936, the building is listed on the National Register of Historic Places.

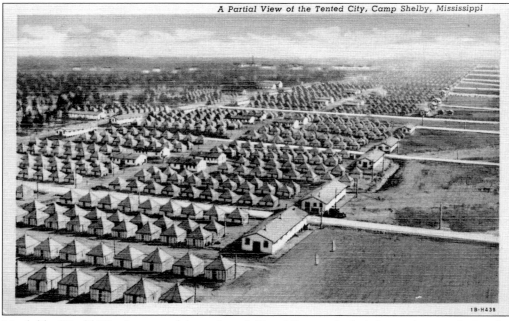

A Partial View of the Tented City, Camp Shelby, Mississippi

1B-H435

Much like World War I, many of the rank-and-file soldiers made their homes in tents during the early days of World War II. Each company was assigned a specific quadrant and camped together. This postcard is titled "a partial view of the tented city."

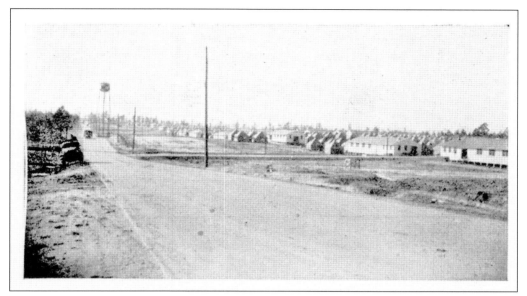

Fourth Avenue was one of the main streets of Camp Shelby in World War II. The description on the back of the card states, "The avenues Highway 24, 2nd Avenue, and 4th Avenue carry the camp vehicle traffic and sixty-six streets connect them to company and regimental areas." Today, Fourth Avenue is named Forrest Avenue.

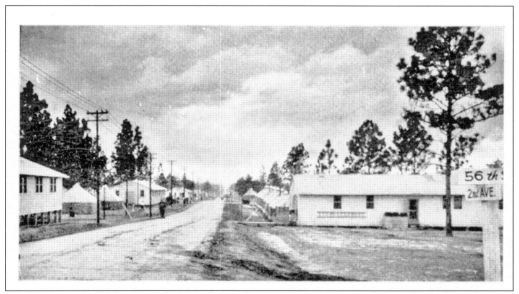

Here is the intersection of Second Avenue and Fifty-sixth Street as it appeared during World War II. Like Fourth Avenue, Second Avenue was a main camp thoroughfare. Both regimental post exchanges and regimental recreation buildings were located on this street.

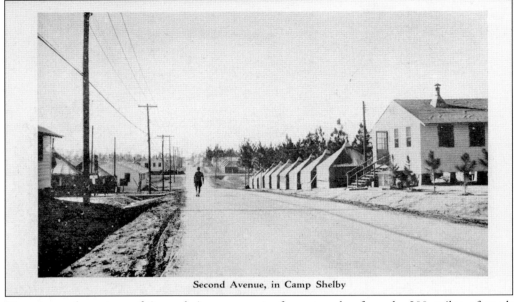

Second Avenue, in Camp Shelby

Here is another view of Second Avenue, part of a network of nearly 200 miles of roads connecting all parts of the base. Although the streets appear empty, more than 50,000 men were stationed at Camp Shelby at any time during the war.

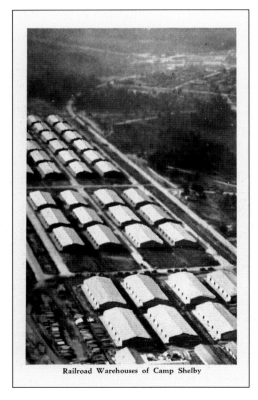

Railroad Warehouses of Camp Shelby

Although the use of motorized vehicles was prevalent in the armed forces by the Second World War, bulk supplies still arrived at Camp Shelby via rail. The warehouses above served as a temporary stop for war materials, as they were distributed from this point by the Quartermaster Corps using a variety of ground transportation. Normally, one Quartermaster Regiment was assigned to each Infantry Division.

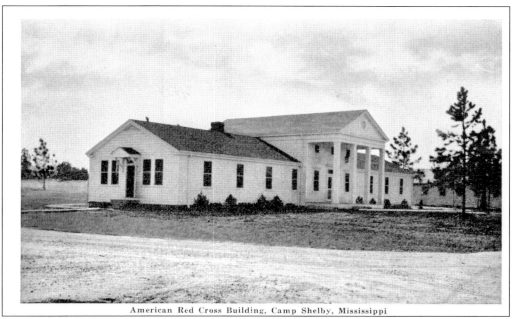
American Red Cross Building, Camp Shelby, Mississippi

The American Red Cross was formed in 1881 under the directorship of humanitarian Clara Barton. Although the Red Cross is not a federal agency, it does have a congressional charter. During World War II, the American Red Cross opened facilities like this one on bases across the nation and gave support to servicemen by helping them communicate with their families, providing emergency loans and grants, and dispensing comfort articles.

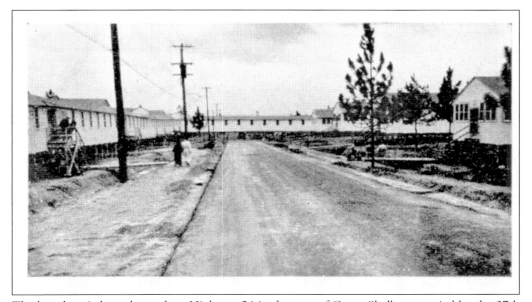

The base hospital was located on Highway 24 in the area of Camp Shelby occupied by the 37th Division. The above view is labeled "a street in the hospital area."

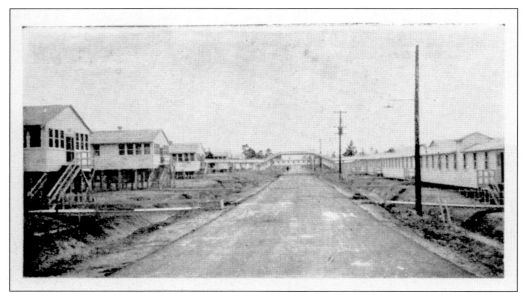

A different view of the hospital area at Camp Shelby is shown here. The base hospital was designed to accommodate 2,000 individuals and was connected by covered walkways or hallways.

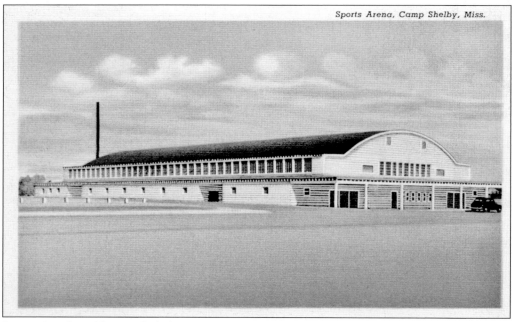

Recreation for soldiers included participation in a variety of sports. Baseball was very popular, as well as football. The Sports Arena above gave the soldiers an indoor area to utilize in times of inclement weather. This building was moved to the campus of the University of Southern Mississippi after the end of the war.

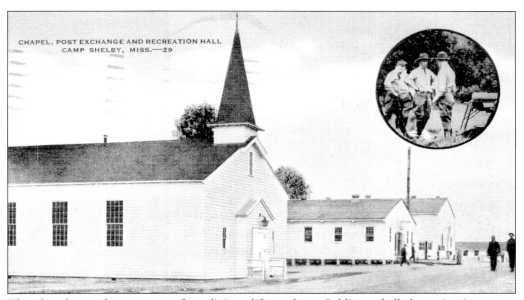

CHAPEL, POST EXCHANGE AND RECREATION HALL
CAMP SHELBY, MISS.—29

The chapel served as a center for religious life on base. Soldiers of all denominations were welcome at the chapel. Many soldiers, however, chose to visit churches in Hattiesburg, where they were welcomed by local citizens. Churches also operated a variety of recreation centers for visiting servicemen.

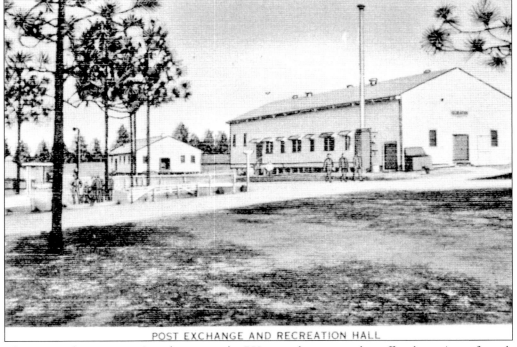

POST EXCHANGE AND RECREATION HALL

The post exchange, sometimes known as the PX, served as a store that offered a variety of goods for sale to base personnel. The image above shows the PX and the adjacent recreation hall. In the lower left, a group of soldiers have gathered to chat and pass the time.

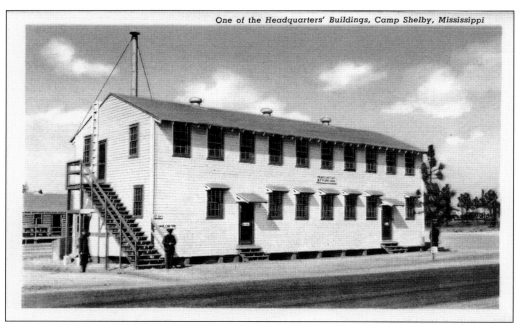

The mass production of postcards often meant the reuse or retouching of individual images. The two images on this page both show the headquarters of the 37th Division, but they are labeled differently, and some minute details are evident. For example, the two men in the photograph appear virtually the same, but power lines are evident in the lower image but not the upper, perhaps erased to make the photograph more aesthetic.

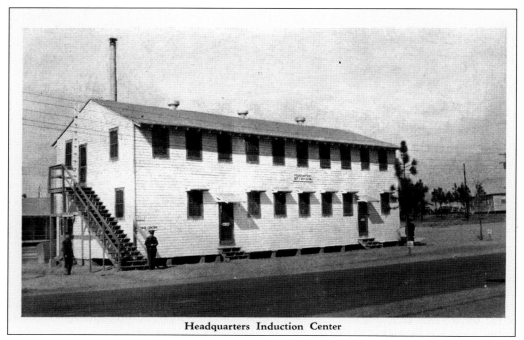

Headquarters Induction Center

Here is another view of the 37th Division Headquarters.

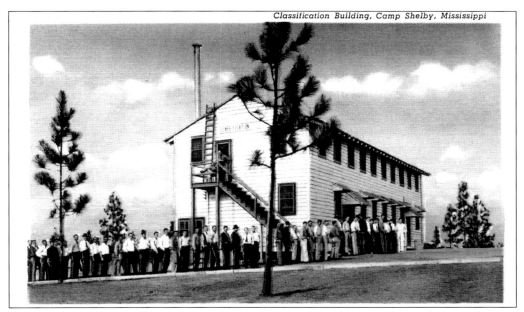

This group of men is posing in front of the classification building at Camp Shelby.

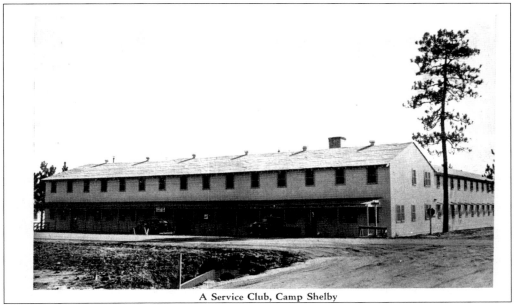

A Service Club, Camp Shelby

Pictured above is the service center for the 38th Division at Camp Shelby. Among the amenities of the service club were guest facilities and dining rooms. The service club also hosted events for the service men, including dances. Soldiers could often be found at the service club when off duty.

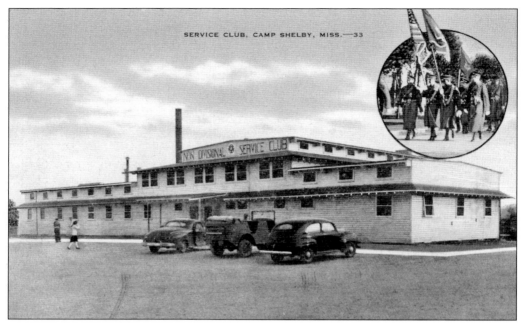

The non-divisional service club at Camp Shelby is pictured here, c. 1942. The young lady entering the facility could be a visitor, a volunteer, or a member of the Women's Air Corps. In addition to army vehicles, two civilian vehicles are also parked outside.

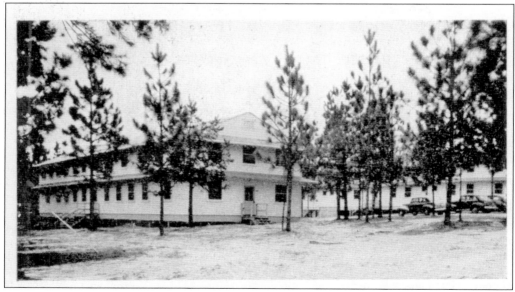

At the beginning of World War II, some officers received a higher grade of housing. The Bachelor's Office Quarters were located on Highway 24 near the 37th Division Headquarters.

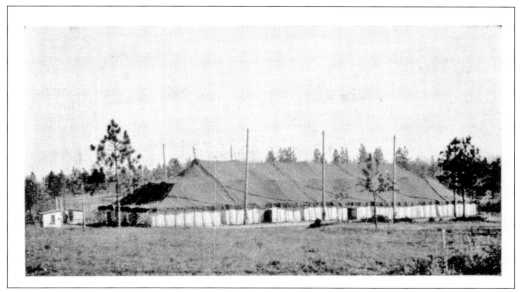

Another popular on-base form of entertainment was motion pictures. Massive tents were erected to serve as movie theaters, and each could accommodate 2,000 service men. Soldiers paid 15¢ to 20¢ admission and could choose from two shows each evening. The movie tents operated seven days per week.

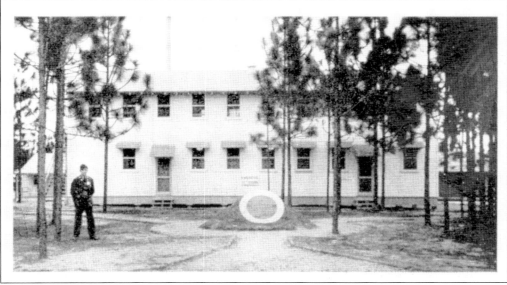

Except for signage, the 37th Division Headquarters appears similar to many of the other buildings on post. Located on Highway 24, the divisional headquarters houses the division commander and his staff. The 37th was known as the Buckeye Division because it was composed primarily of National Guard troops from Ohio. The large mound in the front of the building features the division insignia, a white circular ring around a solid red center. After training at Camp Shelby, the division was sent to the Pacific Theater.

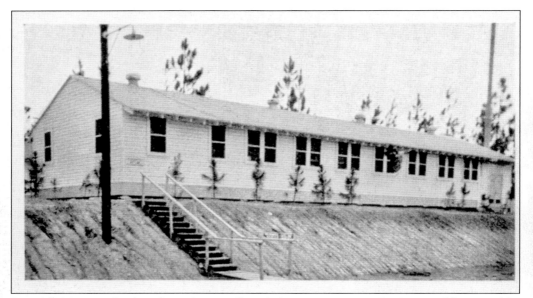

Army divisions are broken down into smaller administrative groups. During World War II, the brigade was usually the next largest grouping, followed by the regiment. A typical infantry regiment included roughly 2,500 soldiers. Pictured above is a typical regimental headquarters building at Camp Shelby.

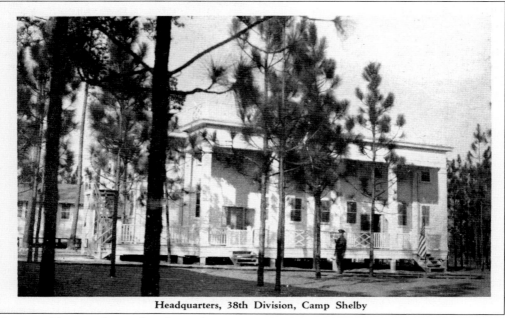

Headquarters, 38th Division, Camp Shelby

Here, a soldier stands guard at the 38th Division Headquarters. After training at Camp Shelby, the 38th Division saw action in the Pacific Theater, where they suffered 3,400 casualties.

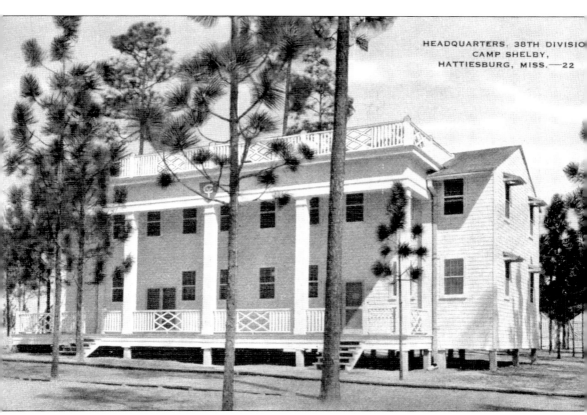

The Headquarters for the 38th Division at Camp Shelby boasted a portico supported by two-story columns. The insignia of the Cyclone Division is proudly displayed on the exterior of the building. As during the First World War, troops from the Kentucky, Indiana, and West Virginia National Guard made up the 38th Division. Although the building no longer stands, the site of the 38th Division Headquarters building is a stop on the current Camp Shelby Driving Tour. The site is near the intersection of Forrest Avenue and Thirty-ninth Street.

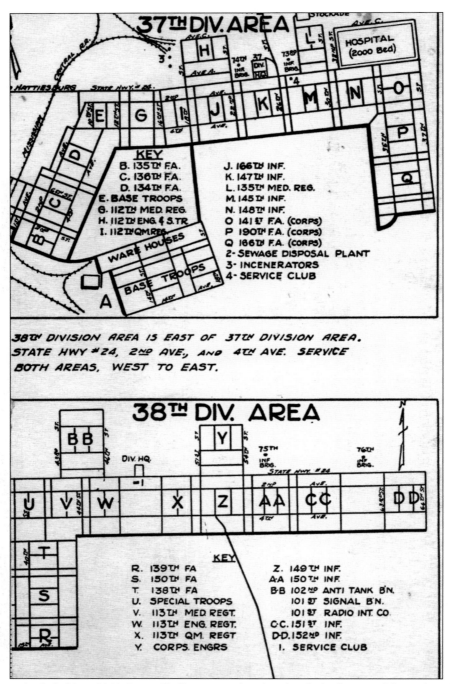

This map included in a 1941 Camp Shelby postcard packet details the layout of the 37th and 38th Division areas at Camp Shelby. Both areas were serviced by the main roadways of the base, Highway 24, Second Avenue, and Fourth Avenue. The 37th Division area was located adjacent to the Mississippi Central Railroad tracks, the base hospital, and the warehouses. The 38th Division area was located to the east of this complex.

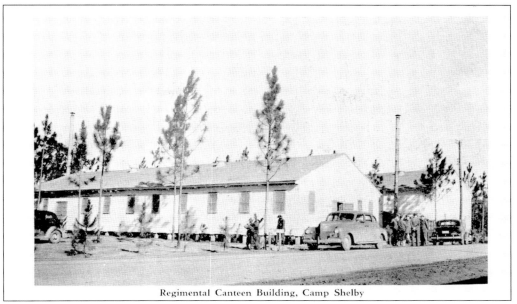

Regimental Canteen Building, Camp Shelby

A group of soldiers is gathered here, outside the regimental canteen.

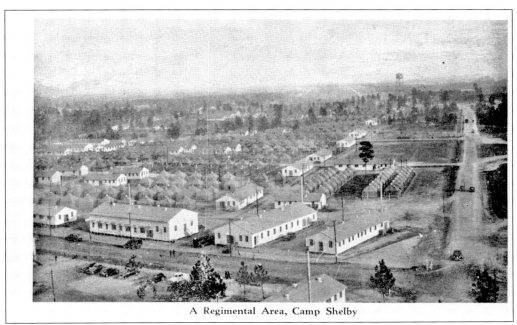

A Regimental Area, Camp Shelby

The first troops to arrive at Camp Shelby during World War II lived in tents similar to those occupied by their World War I predecessors. By 1943, nearly 11,000 buildings had been constructed on the base, and for the most part, the tents were no longer in use. Notice the carefully arranged pattern that separated regiments.

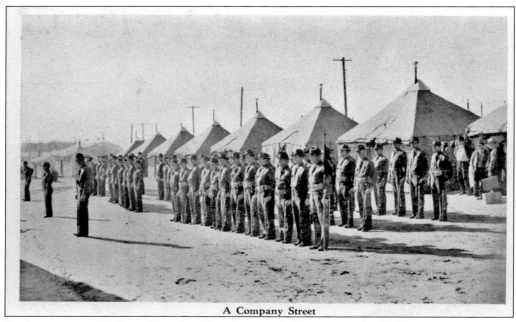

A Company Street

Regiments were broken down into battalions and then into individual companies. Here, a company is in formation for review. Most infantry companies contained 160 to 190 men.

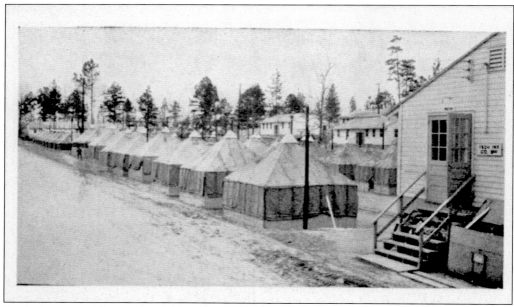

Regiments were housed together at Camp Shelby and then broken down into individual company streets. Tents housed up to six soldiers, thus earning them the nickname "six-man tents."

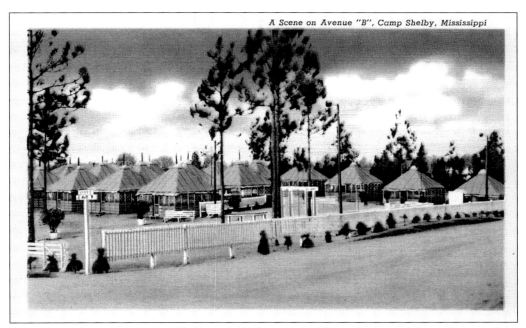

Servicemen stationed at Camp Shelby quickly became familiar with the dominant feature of the landscape: the pine tree. Much of the 300,000-acre base that was not occupied by man was occupied by the conifer.

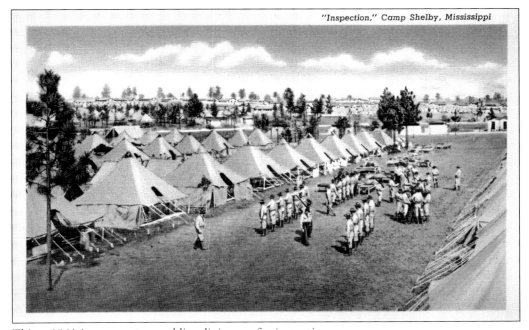

This c. 1941 image portrays soldiers lining up for inspection.

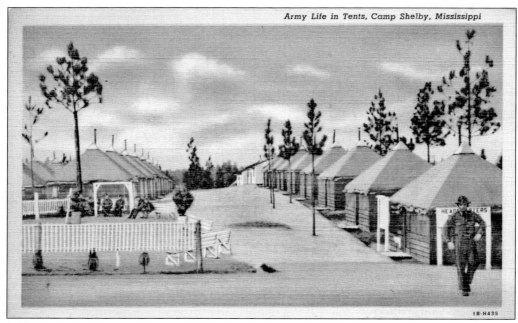

Army Life in Tents, Camp Shelby, Mississippi

Here is an up-close view of life under the pines. Soldiers often complained that South Mississippi was miserably hot during the summer and cold and damp during the winter. Several soldiers can be seen relaxing on the benches to the left.

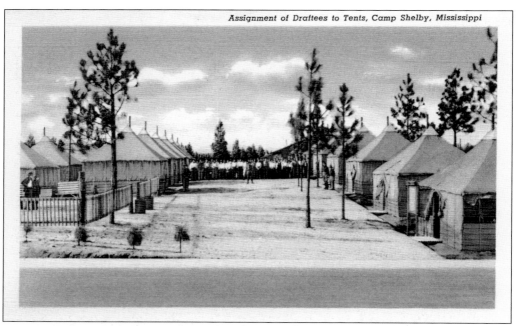

Assignment of Draftees to Tents, Camp Shelby, Mississippi

Shown here is a new group of soldiers awaiting assignment to their quarters. In addition to the 37th and 38th Divisions, the 31st, 43rd, 65th, and 69th Divisions trained at Camp Shelby during the war. Portions of other United States Army divisions trained at the piney woods facility as well, including the 442nd Regimental Combat Team, composed of Japanese Americans.

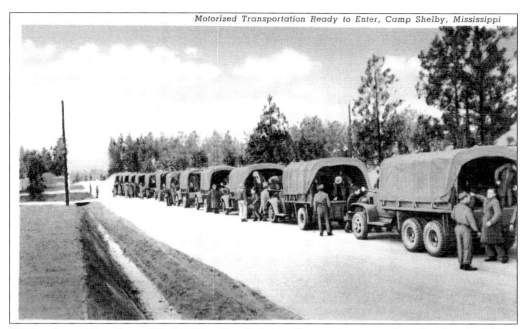

While the soldier from World War I relied heavily on horses and mules for individual transportation and to carry equipment, the soldier of World War II relied on mechanized transportation. Truck convoys became a common site in South Mississippi during World War II, and Highway 49 was widened between Hattiesburg and the base to accommodate the additional traffic.

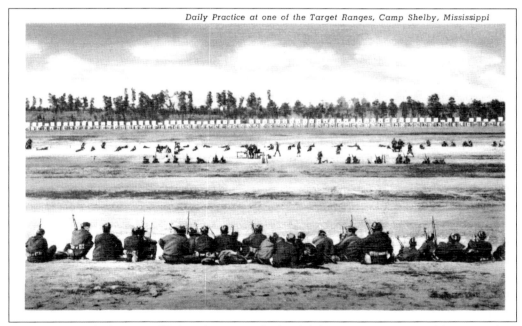

Days at Camp Shelby were filled with practice for battlefield situations. Here, soldiers wait their turn on the firing range. The soldiers in front are practicing marksmanship in the prone position.

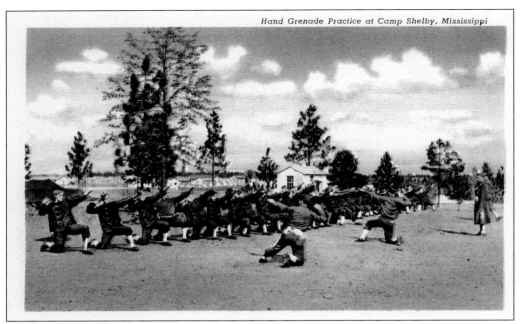

Hand Grenade Practice at Camp Shelby, Mississippi

Another basic skill that the soldier needed to master was the use of the hand grenade. These small but powerful weapons could be deadly when used correctly. Instructors are drilling the cadets on proper throwing technique.

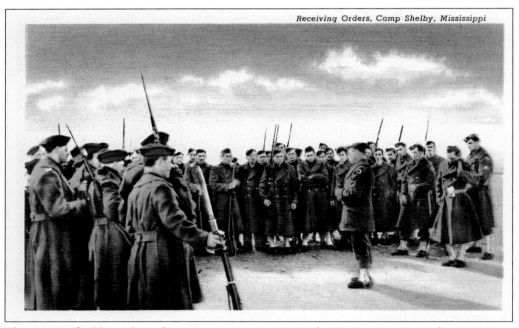

Receiving Orders, Camp Shelby, Mississippi

This group of soldiers, dressed in winter gear, is at ease and waiting to receive orders.

118

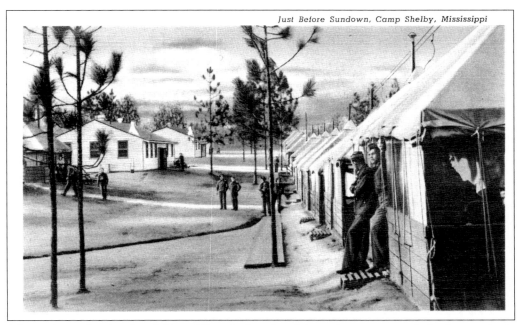

After a long day in the field, soldiers had a few leisure hours to unwind. Appropriately named "Just Before Sundown," this vintage image pictures soldiers as they spend the dusk hours relaxing.

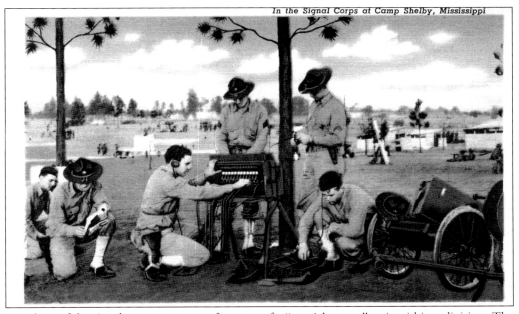

Members of the signal company were often part of a "special troops" unit within a division. The duty of the signal company is to provide effective communication for the troops in the division.

119

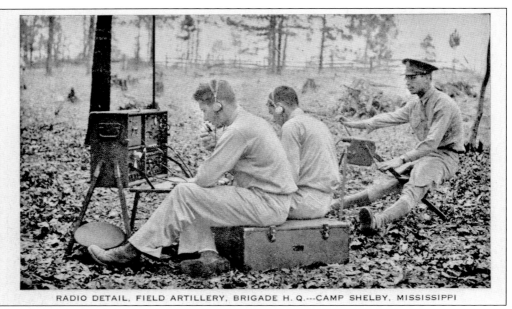

RADIO DETAIL, FIELD ARTILLERY, BRIGADE H. Q.---CAMP SHELBY, MISSISSIPPI

New technology shaped the role of the soldier during the Second World War. Radio technology was no exception. Wireless communication became a vital part of the chain of command, as officers could make direct contact with the front lines.

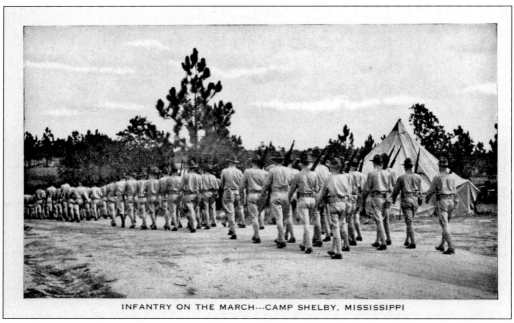

INFANTRY ON THE MARCH---CAMP SHELBY, MISSISSIPPI

Camp Shelby trained hundreds of thousands of troops for action during World War II. Shortly after the war, the base was once again closed. During the Korean War, the base was developed as an emergency railhead facility, and in 1956, Camp Shelby was named a permanent training site. Troops have also trained at Shelby for the Vietnam Conflict, the Persian Gulf War, and the War on Terror.

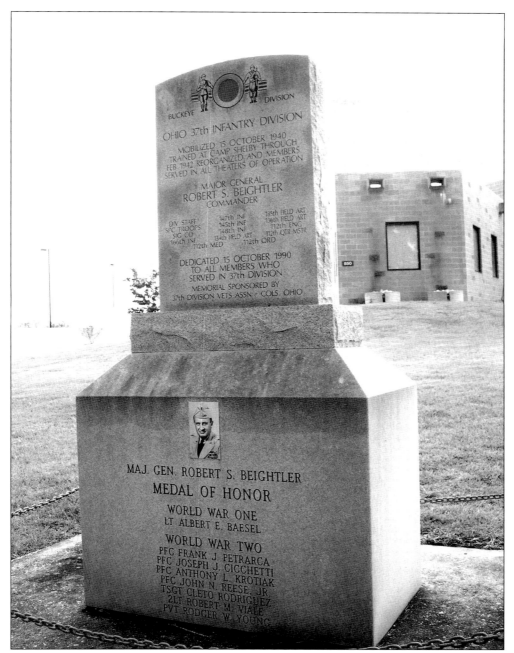

The 37th Division Monument is located outside of the Armed Forces Museum. Incorporated in 1988, the Armed Forces Museum is located at Camp Shelby. The mission of the facility is to honor the service and sacrifices of Mississippi's servicemen and women of all branches and those from other parts of the country that trained in Mississippi during times of war. The museum moved into a new building in 2001 and currently houses a variety of exhibits, including a reconstruction of a World War I trench and a replica of the six-man tent that so many Camp Shelby soldiers once called home.

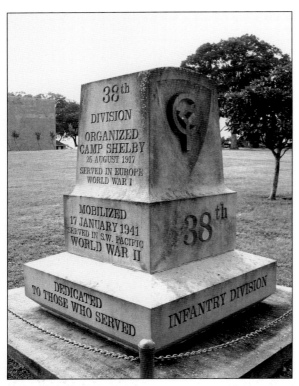

Monuments to many of the units that trained or served at Camp Shelby during World War II are located outside of the Armed Forces Museum. This is the monument to the 38th Division, also known as the Cyclone Division.

This historical marker was placed at Camp Shelby by the Kentucky Historical Society. The marker notes the connection between the Bluegrass State and the piney woods military camp.

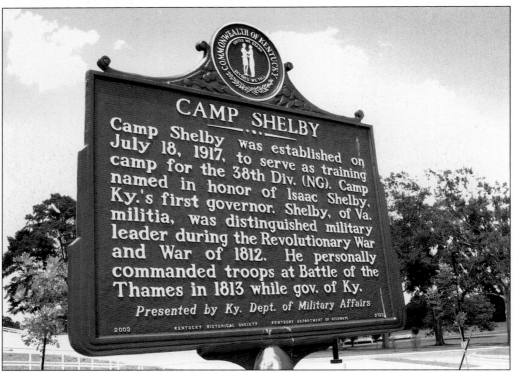

Six
SEND ME A POSTCARD

A few postcards associated with Hattiesburg do not fit into an assigned category. The card above, while labeled "How We Do Things at Hattiesburg, Miss." is a card that was re-titled and sold in other markets across the United States. The actual place portrayed on the card is unknown. This type of card was popular with postcard senders, however, particularly for the comic relief it provided.

The unusual feature of this vintage card is the material of which it is fashioned: leather. This card was mailed from Hattiesburg in November 1906. The sender notes that it was "hot last night and today" and that it "rained all day." Leather cards are a collectors' item more for their format than for the locale that they represent.

This extremely rare card was mailed during the first decade of the 20th century from Ceylon to Hattiesburg. Today known as Sri Lanka, this island nation is located off of the southeast coast of India. The card features five black-and-white photographic images of life in Ceylon.

Similar to the cards on pages 11 and 87, this card features the classic "Greetings from Mississippi" message. The images inside the letters of "Mississippi" are all from the Magnolia State and include the Biloxi Lighthouse, shrimp boats, and the governor's mansion. The State Capitol Building is located in the lower right. This card had a broad appeal to tourists visiting all parts of the state.

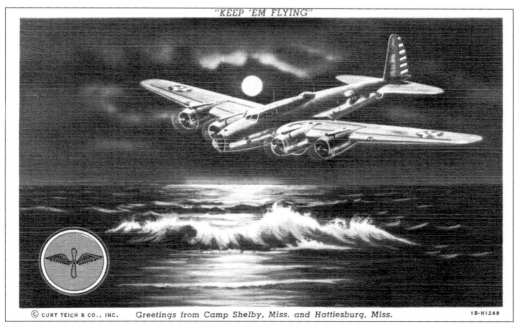

This World War II–era patriotic card features a bomber and urges the recipient to "Keep 'Em Flyin." The card bears the title of Camp Shelby, Mississippi, but was likely re-titled and sold with the names of other military bases in different locales.

Cards with patriotic messages sold briskly during World War II. Postcards were an effective and popular way by which servicemen could communicate with loved ones. Cards such as this one had a dual meaning; they advertised war bonds but also sought to shape public opinion. What recipient could help but empathize with the soldier setting off for war, perhaps never to return?

BIBLIOGRAPHY

Davis, Dyer and David B. Sicilia. *Labors of a Modern Hercules: Evolution of a Chemical Company.* Boston: Harvard Business School Press, 1990.

English, Andrew. *All Off For Gordon's Station.* Baltimore, MD: Gateway Press, Inc., 2000.

Hardy, Toney A. *No Compromise With Principle: Autobiography and Biography of William Harris Hardy.* New York: American Book-Stratford Press, 1946.

Hattiesburg Area Historical Society. *The History of Forrest County.* Hattiesburg, MS: The Society, 2000.

McCarty, Kenneth G., ed. *Hattiesburg: A Pictorial History.* Jackson, MS: University Press of Mississippi, 1982.

Miller, George and Dorothy Miller. *Picture Postcards in the United States, 1893–1918.* New York: Clarkson N. Potter, Incorporated, 1976.

Mississippi: The WPA Guide to the Magnolia State. Jackson, MS: University Press of Mississippi, 1988.

Morgan, Chester M. *Dearly Bought, Deeply Treasured: The University of Southern Mississippi 1912–1987.* Jackson, MS: University Press of Mississippi, 1987.

Monahan, Valerie. *An American Postcard Collector's Guide.* Poole, United Kingdom: Blanford Press, 1981.

Postcard Collection, McCain Library and Archives, The University of Southern Mississippi, Hattiesburg, Mississippi.

Rowe, Melodia. *Captain Jones: Biography of a Builder.* Hamilton, OH: Hill-Brown Printing Company, 1942.

Rowland, Dunbar, ed. *Mississippi: Comprising Sketches of Counties, Towns, Events, Institutions, and Persons, Arranged in Cyclopedic Form.* 3 vols. 1907. Reprint, Spartanburg, SC: Reprint Company, 1976, reprint.

Schmidt, William T. "The Impact of The Camp Shelby Mobilization on Hattiesburg, Mississippi, 1940–1946." Ph.D. dissertation, The University of Southern Mississippi, 1972.

Vertical File Collection, McCain Library and Archives, The University of Southern Mississippi, Hattiesburg, Mississippi.

Vertical File Collection, Mississippi Department of Archives and History, Jackson, Mississippi.

Watson, George R. *Historical Hattiesburg.* Hattiesburg, MS: N.P., 1974.

INDEX

38th Division, 86, 88, 91-93, 95, 107, 110-112, 116, 121

37th Division, 103, 106, 108-109, 112, 116, 122

American Legion Civic Center, 11, 29

Bouie River, 8, 45

Camp Shelby, 9, 20, 29, 85-86, 87-122, 125, 127

Carter Building, 17, 26, 62

Carter, J.P., 26

Churches: Baptist, 9, 55-56, 58-60, 83-84; Catholic, 55, 57, 94; Methodist, 11, 50, 55-56, 60; Presbyterian, 30, 55-57

Columbia, Mississippi, 32

Cook Library, 76, 80

Crawford, Dr. W.W., 50-51

Curt Teich, 6, 7, 87

Elk's Lake, 46

Forrest Hotel, 11, 63

Forrest County Courthouse, 17, 19, 20-21

Freedom Summer Trail, 20, 30

Gulfport, Mississippi, 8, 12, 38, 43-44, 62

Hardy, William Harris, 8, 37, 44

Hattiesburg City Hall, 22-23

Hattiesburg Traction Company, 15

Hattiesburg schools, 11, 28, 31, 57

Henley, D.B., 7, 43, 45

Hercules Powder Company, 34

Hospitals and Infirmaries, 48-51, 57, 78, 103-104, 112

Hotel Hattiesburg, 7, 61-63

Hub City sign, 8, 12, 14, 27

Hunt, R.H., 9, 73, 38

Jones, Joseph Thomas, 44, 62

Kamper Park, 19

Kennard, Clyde, 76, 80

Kress Department Store, 17-18

Lake View Park, 11, 47

Lee, Robert E., 22, 29, 31

Libraries, 11, 30, 76, 80, 82

Lindsey Wagon Company, 42

Lucas Administration Building, 75

Masonic Lodge, 29

McCain, William D., 81

McLeod, John A., 52

Newman, J.J. Lumber Company, 8-9, 35-36

Owl Drug Store, 24, 64

Parkhaven, 54

Perry County, 19, 21

Post Offices, 8, 11, 21-22

Railroads, 9, 12-13, 35, 45, 53, 65, 72; Gulf and Ship Island, 8, 34, 44, 48-49, 62; MS Central, 8, 9, 27, 34, 36, 73, 112; Natchez and East, 8; New Orleans and Northeastern, 8, 37-38, 44; Pearl and Leaf River, 36; Southern Railway System, 38

Reliance Manufacturing Company, 32

Ross, Dr. T.E., 27, 48

Ross Building, 8, 12, 14, 27, 62

Smith, Vinson B. Jr., 9, 75, 77

South Mississippi College, 9, 82-84

Sumrall, Mississippi, 8, 9, 35

Tatum, W.S.F, 8-9, 52, 83-84

Thames, W.I., 9, 82

University of Southern Mississippi, 6, 9, 11, 15, 30, 73-81, 104

Washington, Dr. Walter, 76, 80

William Carey College, 7, 9, 15, 81, 83-84

YMCA, 11, 27-28, 94